D1550617

Barry Galdwater

Photographs by

BARRY M. GOLDWATER

THE ARIZONA HIGHWAYS COLLECTION

By ROBERT STIEVE *and*
ALISON GOLDWATER ROSS

Alison Goldwater Ross

Editor: ROBERT STIEVE
Designer: BARBARA GLYNN DENNEY
Photo Editor: JEFF KIDA
Books Editor: KELLY VAUGHN
Copy Editor: NOAH AUSTIN
Chief Archivist: LORAN HYGEMA
Conservator: STEPHEN BROWNLEE
Master Printer: EVE OLSEN

Photographs provided by the Barry & Peggy Goldwater Foundation.

Library of Congress Control Number: 2019900489
ISBN: 978-0-9989812-6-0
First printing: 2019. Printed in Canada.

Published by the Book Division of *Arizona Highways* magazine, a monthly publication of the Arizona Department of Transportation, 2039 W. Lewis Avenue, Phoenix, Arizona, 85009, www.arizonahighways.com.

Publisher: Kelly Mero
Editor in Chief: Robert Stieve
Senior Editor/Books: Kelly Vaughn
Managing Editor: Noah Austin
Associate Editor: Ameema Ahmed
Creative Director: Barbara Glynn Denney
Art Director: Keith Whitney
Photography Editor: Jeff Kida
Production Director: Michael Bianchi
Production Coordinator: Annette Phares

Dedicated to the memory of
Barry and Peggy Goldwater

CONTENTS

FOREWORD 6

THE BARRY & PEGGY GOLDWATER FOUNDATION 10

BARRY GOLDWATER 12

THE ROYAL PRINTS 31

PHOTOGRAPHS BY BARRY M. GOLDWATER 38

A PASSION AND A PURPOSE 124

AT THE END OF THE DAY ... 128

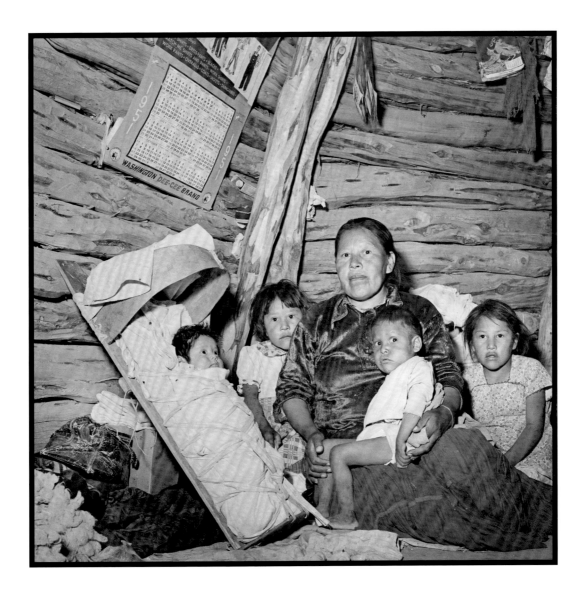

This image is one of many that appeared in *The Eyes of His Soul: The Visual Legacy of Barry M. Goldwater, Master Photographer*, a beautiful book that was edited by Barry's son, Michael. "This is Sally Sundust and her four children," Barry said. "I knew her from the Indian School. The boy in her lap fell off a wagon and the wheels ran over his legs. I drove her down to the hospital at Tuba City, 90 miles away. She didn't have the faith in white doctors that I had. She liked medicine men. The next night, or two nights, she got a horse and got the kid out of the hospital and rode home, all the way back up there on horseback. I later flew that boy and his mother down to Phoenix and had a good friend of mine here — a doctor — look at him and see if there was anything he could do. Years later, I ran into that boy on the reservation and he was all crippled up."

FOREWORD

I met Alison on a Saturday morning. At a parade. We were introduced by a mutual friend, one of the few hippies in Old Town Scottsdale. Like most parades, Parada del Sol is loud. It's hardly a place to hatch a plan, but that's where this began. *This book. This collaboration. This attempt to rescue valuable artifacts.*

Despite the commotion, Alison pulled me aside and started talking — 2,600-pound Percherons, hell-bent tuba players and varsity cheerleaders are no match for Alison Goldwater Ross. She needed help.

"I'm trying to preserve my grandfather's archive," she said. "There are thousands of negatives and transparencies. And they're disintegrating. Film deteriorates. *Did you know that?* If we don't do something, all of that history will be lost."

She spoke with a sense of urgency. Like Paul Revere that night in Boston. I don't think she ever came right out and asked for help, but she didn't have to. I'd been looking for something like this for a while. Something that might transcend the pages of our magazine. When she finally took a breath, I shared my vision. And then we started brainstorming — right there on the corner of Main Street and Brown Avenue. Two years later, the firstborn of that

collaboration arrived.

Our December 2018 issue, which featured the remarkable photography of Barry Goldwater, became one of our best-selling issues ever, and eventually sold out on the newsstand. It was a big hit with subscribers, too, who flooded us with letters to the editor.

"There will be times that I may share a copy of *Arizona Highways* with a friend, but your issue on Barry M. Goldwater will never leave my possession," wrote Annie Shimp of Prospect, Kentucky.

Marjorie Tripp of East Baldwin, Maine, wrote to us, too. "After reading the articles and looking at his photographs, I realized that the man I thought was gruff and unbending in 1964 was not that way at all," she said. "His photographs showed the man inside — caring of people, his state and making a record for the years to come. Only a truly great person could have taken those pictures."

And then there was Joy Burnett of Gold Beach, Oregon, who began her letter with a disclaimer: "I broke my arm a week ago, and am typing with one finger." She went on to say: "I just had to express my happiness about this special issue. Every photograph was stunning and beautiful. Each page more awesome than the last."

Because of the overwhelming response, we made the easy decision to convert that December issue into a book. As you work your way through, you'll notice that we refer to our subject as "Barry," instead of "Mr. Goldwater." That decision wasn't made out of disrespect. In fact, our instinct was to use the more formal style. However, when I asked his family what his preference would be, they were unequivocal: *Barry!* So, with all due respect, we've acquiesced and kept it casual. What's most important, he would say, are the photographs.

"My photographs have been taken primarily to record what Arizona looked like during my life," Barry said. "The first photograph I sold to *Arizona Highways* was in 1939. [Editor Raymond Carlson] and I were driving along one day by Coal Mine Canyon up near Tuba City. Ray said, 'You wouldn't have a picture of that, would you?' I said, 'Yeah, I've got a good one.'"

The image ran on page 16 of our August 1939 issue. It was just the beginning. Many more have followed, including a portrait from June 1940 that Barry titled *The Navajo*. "That's one of my better pictures," he said. "It was taken back in 1938 at an Indian fair near Window Rock. His name is Charlie Potato, and I guess I must have printed maybe 5,000 of those."

The Navajo is one of our favorites, too, which is why we used it as the opening photograph in this book. The runner-up for that spot was a photograph that's sometimes referred to as *The Shepherdess*. It first ran on the cover of our December 1946 issue. You might remember it. Arguably, it's the most famous photograph we've ever published in the magazine.

"It was a cold, raw winter day deep on the Navajo Reservation when Barry Goldwater took the picture we use on our cover," Raymond Carlson wrote in his column that month. "The snow clouds were low over Navajo Mountain and the little Navajo girls, watching their sheep, were wrapped in their blankets against the wind. The whole scene is real and simple."

Turns out, that issue — with Barry's now-legendary image on the front cover — marked the first time in history that a nationally circulated consumer magazine was published in all color, from cover to cover. In the annals of magazine publishing, that's significant, but to Barry, it was something more.

"The great thing about photography," he wrote, "is that through it, I was able to enjoy my state as it was growing

up, and capture some of it on film so other people could have a chance to see it as I knew it. To photograph and record Arizona and its people, particularly its early settlers, was a project to which I could willingly devote my life, so that I could leave behind an indexed library of negatives and prints."

When you do the math, there are more than 15,000 slides and transparencies in his archive, along with 25 miles of motion picture film. As he'd requested, many of his images are housed at the Center for Creative Photography at the University of Arizona, the Hayden Library at Arizona State University and the Heard Museum in Phoenix. The rest are with the Barry & Peggy Goldwater Foundation, the nonprofit formed by Alison to preserve her grandfather's legacy.

Unfortunately, all of his images are in need of preservation — even under the best of circumstances, film deteriorates over time. What's worse, as the film slowly disintegrates, so do important pieces of Arizona history. Priceless artifacts.

"What I'm setting out to do with the foundation is to fulfill his wishes," Alison says. "His wishes were to document Arizona and show the beauty of the landscape and the people."

The task of doing that — through digitization and optical restoration — will be costly and time-consuming, but the work has already begun, and you'll see some of the results in this book. *The Navajo, The Shepherdess, Big Country* ... for us, getting access to the family archive and beyond was like being let loose in Copenhagen's Conditori La Glace at Christmastime. There were so many photos to choose from. It was a real challenge. And so was writing the captions.

Although Barry created an elaborate filing system, indexed by subject, he could be stingy with details. And, sometimes, he'd give multiple names to the same image. Where the information was thin or confusing or nonexistent, we relied on commentary from other photographers, including Ansel Adams, who, like our subject, was a longtime contributor to *Arizona Highways*.

"Senator Goldwater's deep involvement in the affairs of the world and at the summit of political activity have undoubtedly limited the time and effort he could expend on his photography," Mr. Adams wrote. "The important thing is that he made photographs of historical and interpretive significance, and for this we should be truly

grateful. We sometimes forget that Art, in any form, is a communication. Barry Goldwater has communicated his vision of the Southwest, and he deserves high accolades for his desire to tell us what he feels and believes about his beloved land."

We also reached out to some of our current contributors. The names are names you'll recognize: David Muench, Jack Dykinga, Paul Markow, Paul Gill, Joel Grimes, J. Peter Mortimer. In addition to being a talented photographer, Pete was our photo editor in the early 1980s. In that role, he often visited Barry at his home in Paradise Valley.

"The first time I met Barry Goldwater," Pete says, "was when Editor Don Dedera asked me to go to Barry's house to get an envelope of photographs that were going to be used in the magazine. As I drove up the driveway, I noticed that the abandoned Secret Service guard shack was still there — a relic from Goldwater's 1964 presidential campaign. Near the driveway, there was a man in dark shorts and a T-shirt slapping a tar-like substance onto an old, ailing saguaro. As I got closer, I realized that it was Senator Goldwater. I rolled down the car window and he said, 'You've come for the pictures?' I told him yes, and then I asked what was wrong with the cactus. He looked over at the saguaro and said, 'Oh, I don't think these damn things like us very much!' Then he added, 'Go up to the house and get some iced tea; I'll be there in a few minutes.' Over the years, I was lucky enough to make a number of trips to his house to get photographs. I always looked forward to hearing him talk about the specific images that he was sending back to the magazine."

In all, we've published hundreds of Barry's photographs in the magazine since that first image in 1939, and now we're proud to be partnering with the Barry & Peggy Goldwater Foundation on this exciting book. And there's more to come. Plans are already underway for museum exhibitions, a line of related products and a movie based on Barry's trip down the Colorado River in 1940, all of which will benefit the foundation in its ongoing effort to preserve those 15,000 images. Stay tuned for details on all of the above. Meantime, on behalf of Alison Goldwater Ross and the entire Goldwater family, we hope you enjoy this important collection of Arizona history.

— *Robert Stieve*

THE BARRY & PEGGY GOLDWATER FOUNDATION

BY ROBERT STIEVE

The mission is simple: to preserve history.

At a glance, the focus seems to be on photography, but the ultimate goal of the Barry & Peggy Goldwater Foundation is to preserve history. Specifically, the history that was documented on film by the foundation's namesake.

Although he's best known as a U.S. senator, a public servant who dedicated his life to Arizona, Barry Goldwater might have been even more passionate about his photography. And it wasn't just a favorite pastime. He saw a greater purpose. "I'm trying to record the history of my state," he said, "so that students, 25, 50, 100 years from now, can find a picture that didn't exist when I started."

In addition to being technically savvy and having a photographer's eye, Barry had access to places that were typically off-limits to most photographers, including the Apache, Hopi and Navajo nations. He was allowed into those places because of the relationships he built with the people. He respected them, they respected him, and, as a result, he was able to photograph people, places and things that, in many cases, had never been seen before.

"He saw the region — historic sites and relics and people — in terms of images," Ansel Adams wrote about his friend and colleague. "He made photographs of historical and interpretive significance, and for this we should be truly grateful."

In all, Barry made more than 15,000 photographs, along with 25 miles of motion picture film. Recently, the foundation obtained the Goldwater family's collection of images, as well as the rights to additional Goldwater collections archived at the Center for Creative Photography at the University of Arizona, the Hayden Library at Arizona State University and the Heard Museum in Phoenix.

Unfortunately, most of those collections are at risk — even under the best of circumstances, film deteriorates over time. What's worse, as the film slowly disintegrates, so do important pieces of Arizona history. The mortality rate of Tri-X and Kodachrome would have surely disheartened our subject, which is what prompted his granddaughter, Alison Goldwater Ross, to establish the Barry & Peggy Goldwater Foundation. "What I'm setting out to do with the foundation is to fulfill his wishes," Alison says. "His wishes were to document Arizona and show the beauty of the landscape and the people."

In 2017, *Arizona Highways* began working with the foundation on this important preservation project. It was an obvious partnership. Barry Goldwater was one of the magazine's first and most important photographers. He

10

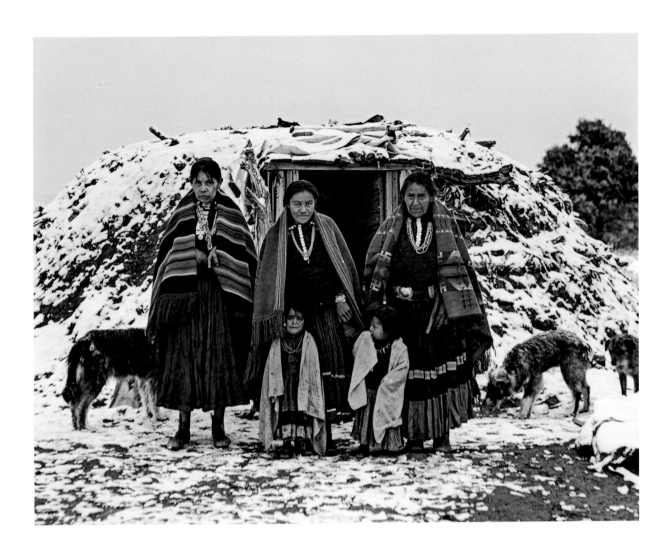

was a contributor for decades, and his photographs are still being used today.

As you can see in this book, his images stand the test of time as pieces of art, but they're also part of the historic record, which is why he made them in the first place.

"It's really important that we don't let this go away forever," Alison says. "We need to save this history. That's my mission. ... That's what I'm doing."

For more information on the Barry & Peggy Goldwater Foundation, please visit www.goldwaterfoundation.org.

"The present-day Navajo are leaving behind some of their traditional ways," Barry wrote in *Arizona*, a coffee table book published by Rand McNally in 1978. "I worked hard [on those words]," he said of the book. "But I had to keep in mind that the photographs would be far more beautiful than my words." The photographs for the book were those of another one of our legendary contributors, David Muench. Barry made this undated photograph on the Navajo Nation.

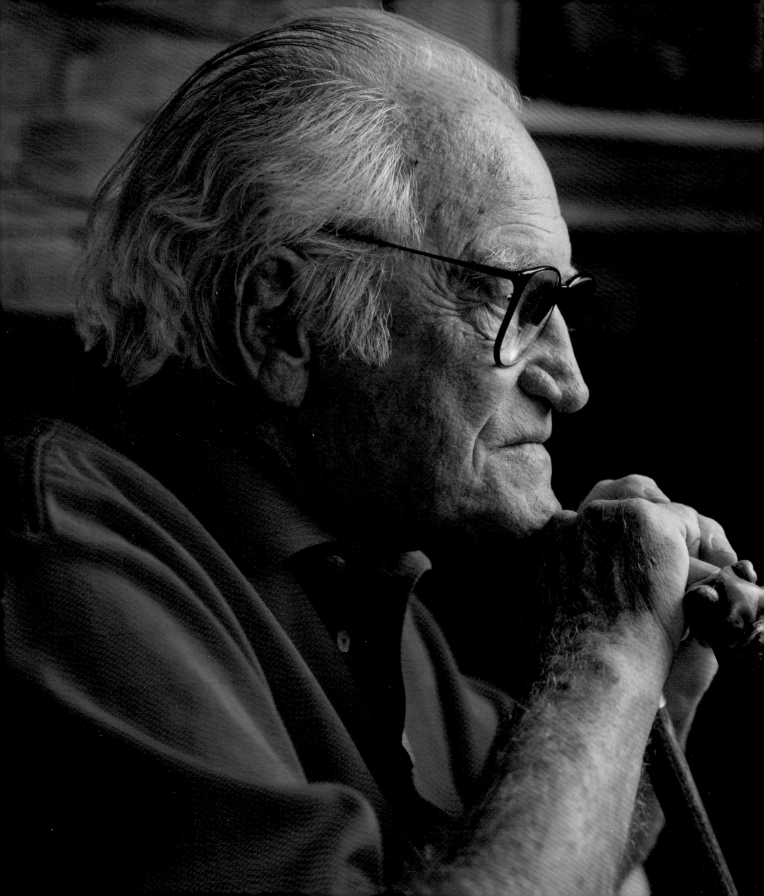

BARRY GOLDWATER

Although he's best known nationally as a longtime senator and
one-time presidential candidate, Barry Goldwater's love of politics may have
been surpassed by his passion for photography. He spent a lifetime carrying
around a camera, and his favorite subjects were the ancient cultures
of Arizona and the state's unparalleled landscapes.

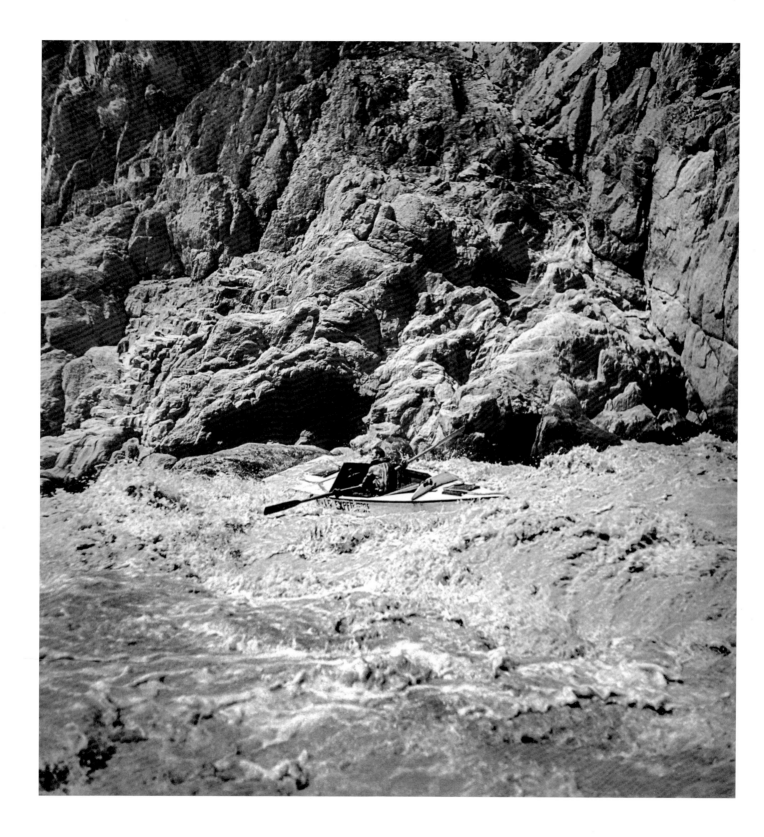

Barry Goldwater looks positively blissful. It's the summer of 1940, and 31-year-old Barry is deep into a journey along the Colorado River that will make him just the 73rd person to travel through the Grand Canyon by boat.

Barry is virtually unrecognizable in the photograph. Wearing a T-shirt, he gazes into the distance, his eyes alive and his smile serene. The high forehead appears familiar, but Barry's trademark jutting jaw is concealed by a thick, dark beard, the kind men grow when the closest mirrors are miles away and wives won't be seen for several weeks more.

Barry had left behind his wife, Peggy, in San Diego that July with the couple's three small children, including son Michael, born just four months earlier. Peggy didn't want her husband to go on the trip, and Barry confessed a measure of guilt at temporarily abandoning his young family.

But he also couldn't resist the opportunity to challenge the fabled rapids with pioneering river runner Norman Nevills, to satisfy what he described as a "long smoldering desire to make the trip down the Colorado River in an open boat." He dubbed it "riveritis."

Crafted by Nevills from half-inch plywood and designed to navigate the Colorado in both its most limpid and its most turbulent extremes, the flat-bottomed boats, which Barry helped build, measured 16 feet long and spanned 6 feet at their widest. On either side of the cockpit, hatch lids, secured tightly by refrigerator handles, protected waterproof compartments, an important consideration for Barry Goldwater. Because he wasn't traveling light.

As a small boy, Barry discovered a Kodak Brownie box camera that belonged to his mother, Josephine. Ever since, he had loved photography. He combined photography, as well as such emerging technologies of his youth as avia-

In 1940, Barry Goldwater became just the 73rd person to run the entire length of the Colorado River. This photograph was made on that trip.

tion and radio, with an abiding fascination for his native Arizona. Long before embarking on the river trip, Barry set out to visit and photograph remote parts of the state, bringing together an artist's eye and an anthropologist's commitment to record his homeland's ancient cultures and timeless, yet fragile landscapes.

So, having graduated from the Brownie to more sophisticated cameras — first a 2¼ Eastman Kodak Reflex (a Christmas gift from Peggy in 1934), later a Graflex 4x5 and a Rolleiflex 3.5 — Barry did what he could to protect his gear and film from the silt-laden waters of a still-undammed Colorado, the river Barry and many others described as "too thick to drink and too thin to plow."

In addition to his still-photography equipment, Barry took along a movie camera, and over the course of the trip, he shot roughly 3,000 feet of footage that would indirectly help him launch the long political career that led to five terms as a United States senator and to the brink of the presidency in 1964.

Barry was both reviled and revered in his time, sometimes by the very same people. He's considered the father of modern conservatism, yet he embraced positions that today would qualify him as liberal. A maverick before that term came into political vogue, he lived the authentic Western life of self-reliance and rugged adventure that Ronald Reagan mostly played on screen.

Through it all, photography and Arizona itself were constants. In the aftermath of his loss in the 1964 presidential race and his departure from the Senate, Barry found solace in the land that he once likened to 114,000 square miles of heaven that God had brought down to Earth.

At a post-election press conference, he declared, "I've got heaven to come home to. Not everybody has."

As if in a hurry to get on with things, Barry Goldwater was born on the very first day of 1909. Three years older than Arizona itself, he watched his mother, known as "Mun," sew two new stars onto the American flag after New Mexico and Arizona earned admission to the union. He came of age during a time when Arizona sat poised between its Old West traditions and the inevitable onslaught of modernity.

Barry was Arizona royalty. The nephew of a prominent politician, he later ran the family department store, which grew out of a business that his grandfather Michael, a Jewish immigrant from Poland, first operated in the lower Colorado River gold-mining boomtown of Gila City in the 1860s.

Phoenix nearly tripled in size during the first 10 years of Barry's life, but even by 1920, fewer than 30,000 people lived in the community. Barry recalled exploring the slopes of South Mountain and Camelback Mountain, and learning to swim in the Salt River. He ran with a group of boys dubbed the Center Street Gang, who found the perfect terrain for their hijinks in the growing desert town and the wilds surrounding it.

His father, Baron, focused on the store and showed little inclination for outdoor adventure, so it was left to Mun, Illinois born and with a frontier woman's pluck, to introduce her three children to the untamed glories of Arizona.

"It all started with his mother," says Barry's son Michael. "She was a wonderful woman — a deadeye rifle shot who fished, hunted and camped."

Young Barry quickly grew comfortable sleeping beneath the stars on the family's many camping trips. They traveled to the Hopi and Navajo lands of Northern Arizona, and Mun drove out from Yuma and into California on the Plank Road, a route constructed of sections of wood laid across the dunes. According to Barry's daughter Joanne, Mun also instilled patriotic values in her children, once a week taking them over to Scottsdale's Indian School Park to salute the flag when it was lowered in the evening.

During the family's travels around Arizona, Barry developed a special passion for the Colorado River: "By the time I was a rather large boy I had seen the Colorado from

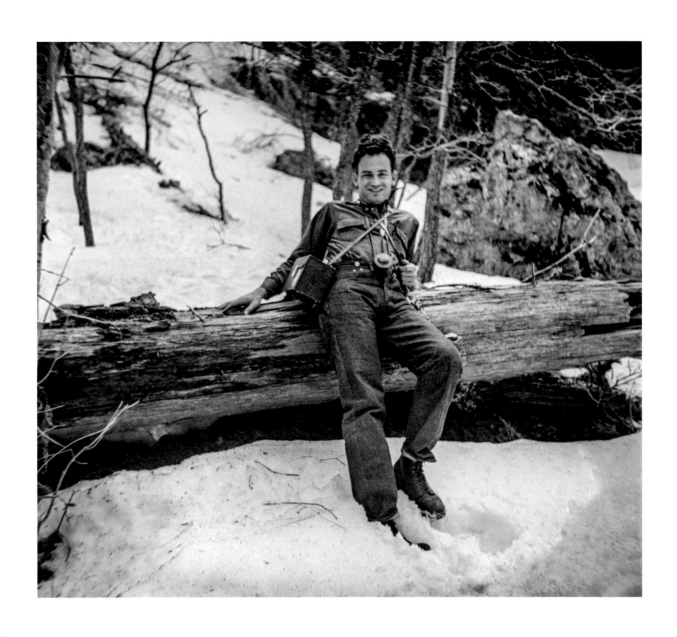

A young Barry Goldwater near Mount Lemmon in 1925, the same year *Arizona Highways* was born.

practically every vantage point in Arizona, from the bottom of the Grand Canyon to the broad expanse of water below Yuma."

If at best an apathetic student, Barry pursued those things that captured his imagination with a passion that lasted a lifetime. An inveterate tinkerer with a deft mechanical touch, he began learning about radios at age 11, after his father gave him a crystal receiver set. Barry boasted in a 1923 letter to none other than Thomas A. Edison that he had "studied electricity since I was a little kid" and operated a 10-watt radio station. By 13, Barry had helped set up KFDA, Arizona's first commercial radio transmitter.

He traced his interest in aviation to a first glimpse of the planes at the 1917 Arizona State Fair, where wing walkers performed and pilots put their primitive aircraft through daring stunts. When he was college age in 1930, and without seeking his parents' permission, Barry began sneaking out of the house early in the morning to take flying lessons. After Mun found out, she wasn't angry; she only wished that he had let her know, so she too could have learned to fly.

Barry would eventually pilot an estimated 255 aircraft, from pokey C-54 cargo planes — which he took across the Himalayas between China, Burma and India as a "Hump flyer" during World War II — to supersonic F-16 fighters. (Serving as Senate Armed Services Committee chairman had its perks.)

The world looks different from above, and flying gave Barry a new perspective on his native land — one that ultimately influenced his photography. At a time when many Arizona roads remained primitive tracks (son Michael tells of one trip between Phoenix and Prescott that took 17 hours because of 13 flat tires), flying also gave Barry quick access to otherwise remote parts of Arizona that he was determined to photograph. He would glide low over the land, searching for unmapped features — arches, natural bridges and cliff dwellings — that he could then return to and shoot.

In 1935, Peggy arranged a small ownership stake in Rainbow Lodge, the trading post and base camp that opened in 1924 for tourists seeking to visit the 275-foot-wide Rainbow Bridge. In those pre-Glen Canyon Dam days, there was no Lake Powell for easy water passage to the formation in Southern Utah, so a 14-mile-long trail was built to connect the lodge and the bridge.

One afternoon, while scouting locations near the head of the trail, Barry ran into a fellow photographer: a shorter man, several years older, with distinctive sleepy eyes and a puckish grin. This was not just any photographer, but Ansel Adams, who recalled the chance encounter that led to a lifelong friendship with Barry: "I met a young man who was obviously pursuing photography, as I was, and with obvious fervor. He introduced himself as Barry Goldwater of Phoenix."

The two shared a reverence for Edward Weston, whom Barry lauded "as the purest of them all" for images that he said attempted to convey "the very substance and quintessence of the thing itself." Barry would follow Weston's inspiration, using direct focus and slow film and shutter speeds while relying on the Arizona sun, which he softened with a yellow filter.

On that day, Barry helped Adams find the easiest route down to Rainbow Bridge, and the two men compared equipment and talked photography. Over the years of their friendship, Barry shared his deep knowledge of Arizona's places and the ways of its Native people, giving the legendary photographer an invaluable understanding of the state. In turn, Adams offered insights into photographic

Peggy and Barry Goldwater, circa 1947.

technique and the secrets of the darkroom, enhancing the processing skills that Barry had first learned from Phoenix portrait photographer Tom Bates.

Barry originally used his home's kitchen sink as his darkroom — much to Peggy's dismay, because she couldn't stand the smell of the chemicals. He eventually established a much more professional setup and was meticulous in his photographic routine.

"The first and best advice I received when I began this hobby was to stay with one film and one developer," he wrote. "There have been temptations to wander, but using the same materials has made my work much easier." He also created an elaborate filing system, indexed by subject and cross-referenced with 8x10 prints, to keep track of his estimated 15,000 negatives.

While Barry was overseas during World War II, Peggy surprised him by purchasing half-ownership in Rainbow Lodge for her husband. He cut a 2,000-foot landing strip, shortening the travel time from Phoenix to two hours or less, and used the lodge as a base for excursions into Navajo Country and some of the nation's least-explored terrain.

Like his mother, Barry was determined to introduce his own children to Arizona. According to Michael: "We would be in grade school, and he would say, 'OK, tell your teachers you have something important to do and you won't be back for a week.' And we'd go out on a camping trip. One year, he took 25 YMCA boys and me and my cousin and brother down part of the Colorado River, from Hite's Landing to Lees Ferry. I was 11 or 12 years old."

In a television interview, Barry's son Barry Jr. said: "He dragged us all over the state. We walked all over every monument, every reservation, every mountain. Every gully, we've been in. And every night, we'd camp out. He taught us how to light a fire, how to survive. How to camp out and keep warm."

The family would set out in the "Green Dragon," the Chevrolet panel truck they used for camping trips around the state — traveling into the borderlands, along the Mogollon Rim and up to the San Francisco Peaks. Barry loved peanut butter, and for more substantial meals, he'd prepare a gravy that he poured over everything from Dutch-oven biscuits to Spam.

"One night in the fall," Joanne recalls, "we were camping out on the San Francisco Peaks, near the ski run. It was family and friends, and after dinner, we were all settled into our sleeping bags. Then, in the middle of the night, I started hearing bells and braying. Dad got up and shouted, 'Everybody into the truck! Get into the truck!' It was a whole huge herd of sheep roaming through the hills and coming right into camp. We had to grab our bags and waited up in the truck until the sheep all passed through. Or they would have trampled right on over us."

To reach Rainbow Lodge, the family sometimes flew, but Joanne also remembers drives in the Green Dragon when, after passing Tuba City and Inscription House, they left established roads and followed wagon wheel tracks etched in the rock. Barry himself said some of the roads he traveled were so bad that even the sheep wouldn't use them.

"It was a true adventure," says Joanne, who was around 12 the first time she made the trip. "That was a pretty desolate area up there on the border with Utah, and it was hard to get to. But the lodge had the cutest little sleeping houses, just big enough for a bed and a sink. They'd feed us in the lodge and people would saddle up to go to the bridge, but some of us walked down. It was a long way, maybe 14 miles. The very first time we got to see the bridge, it was just so awesome. We loved to go out with Dad. He sure showed us Arizona. *His* Arizona. It was wonderful."

In August 1951, a fire destroyed most of Rainbow Lodge. After learning of the blaze, Barry flew from Phoe-

Barry and Peggy Goldwater's children, circa 1947. From left to right: Michael, Joanne, Peggy and Barry Jr.

nix to Navajo Mountain, passing over the Grand Canyon to show off the gorge to his friend Charles Ray. Looking to the left, Barry noticed what he thought might be a previously undiscovered arch in Nankoweap Canyon. Heading home, he returned to the location, but in the afternoon light, he could no longer locate the formation.

A year later, Barry again glimpsed the arch from the air. After identifying it a third time during another flight, he decided to embark on a river trip in 1953 to find the span. But by then, he was serving as U.S. senator from Arizona, and the demands of his duties in Washington prevented him from traveling down the Colorado.

Barry came up with a solution: A friend, Bob Gilbreath, owned a helicopter company, and Barry asked him to haul one of his aircraft to Cameron. From there, the pair would fly to the bottom of the Canyon, then hike to the arch. With the sun rising on what Barry described as a clear morning, Gilbreath flew about 300 feet above the landscape, passing over the Little Colorado River Gorge and its junction with the main Canyon, before setting down on the south bank of Nankoweap Creek around 8 a.m.

Despite a few miscalculations — most notably, failing to identify a waterfall that blocked their passage, forcing the two men to backtrack — around 1:30 p.m., Barry and Gilbreath reached a point that offered a complete view of the limestone arch, 200 feet wide and equally tall. It was the culmination of a quest that had begun four years earlier.

"By then," Barry wrote, "I was exhausted, and every muscle in my body ached, but a great peace and calmness came over me as I realized that here at the end of this arduous trail was that which I had been seeking.

"I sat there and wondered if any other white man had looked upon this thing from such a close vantage point. I suspected that Indians in the past had traveled up here because we found pottery down below, and because we knew that Indians at one time lived at the mouth of Nankoweap. None of the usual evidence of man's visits, however — tin cans, empty cartons and the like — disturbed

the cool calmness of this bit of God's handiwork."

Following Barry's suggestion, the formation now is named Kolb Arch to honor Ellsworth and Emery Kolb, the brothers who operated a photo studio on the South Rim and in 1911 filmed the first motion pictures of the Colorado River's rapids in the Grand Canyon.

In 1916, when he was just 7, Barry persuaded John Rinker Kibbey, an architect and family friend, to let the young boy accompany him on a trip to the Hopi mesas. Barry recalled that Kibbey, one of the country's first major collectors of kachinas, put up with his endless questions and bought a 24-inch Mudhead Kachina figure. The price: $3.

Looking back, Barry believed the trip left a lasting impression, helping establish his lifelong connection to the Colorado River: "In a vague, symbolic way, it was for me almost a return to an ancestral homeland. Streams heading in Tusayan washes flow out from Black Mesa, which is Hopi Country, onto the barren northern plateau, eventually reaching the Little Colorado River, which then joins its mother stream, the Colorado River.

"Lower on down on the Colorado, at La Paz and Ehrenberg, my grandfather 'Big Mike' Goldwater had established his first stores in Arizona. Somehow I have always felt a close association with the Colorado and its drainage basin within my native state. This feeling of kinship with the Colorado River country played a significant role in interesting me in the people and artifacts of the Black Mesa country."

The trip also inspired Barry's fascination with Arizona's Native American cultures. He eventually began his own kachina collection. Then, after World War II, he cleared out his savings account and purchased Kibbey's figures for $1,200. Over the years, the combined collection, which spans a period from the late 1800s to the 1960s, grew to 437 kachinas before Barry donated the pieces to Phoenix's Heard Museum while running for president in 1964.

"It's a tremendously important collection," says Ann

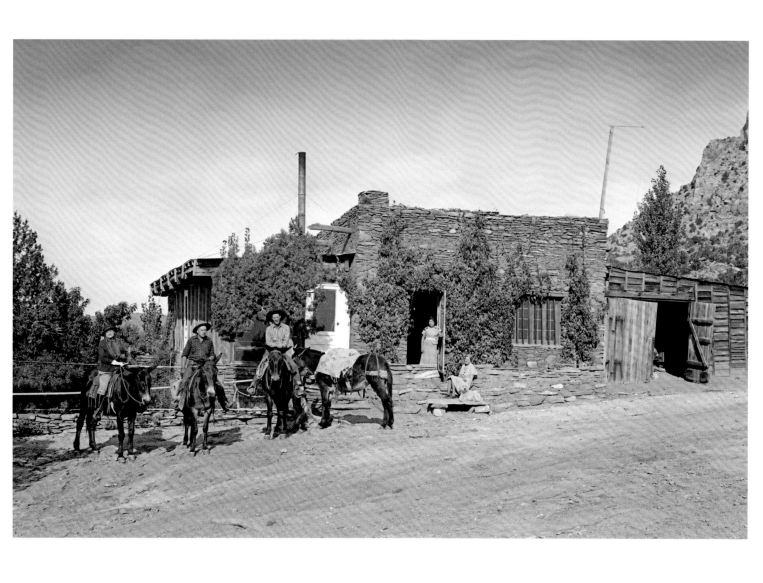

Unidentified men and women at Rainbow Lodge on the Navajo Nation, circa 1938.

Upon first crossing into Arizona from Utah, Barry wrote, "I noticed immediately a more bracing quality in the air; a clearer, bluer sky; a more buoyant note in the song of the birds; a snap and sparkle in the air that only Arizona air has, and I said to myself, without reference to a map, that we were now home."

Marshall, director of research at the Heard. "They're fascinating pieces, really, and remain a critical part of the Heard's collection. Some of them come from a time almost before kachina dolls were carved for sale. They go through all of the different phases of carving, and some are quite unique in terms of their styles. You can pick out many pieces that are incredibly special."

For all the artistic value, Marshall says, the collection is most notable for its comprehensiveness, in part because Barry commissioned Oswald White Bear Fredericks, a prominent carver, to create 90 additional dolls. She says those figures fill in gaps and allow the museum to portray the full range of kachina ceremonies.

In other words, Barry assembled the collection with an anthropologist's eye. "It speaks to Goldwater's understanding that this was a subject of great breadth and complexity," Marshall says. "He wasn't narrow; he was truly trying to get something that gave a picture of the incredible importance of these carvings in Hopi culture."

Barry adopted a similar approach with his photographs of Native American cultures. "I've shot a lot of landscapes, but I'm proudest of my Indian photography," he said. "I think I've got as good a recording of the Indians of Arizona as has ever been done — every tribe, and parts of tribes that hardly anyone's ever heard of."

There are many photographs of Hopis and Navajos, of course, but also pictures of Tohono O'odhams, Apaches, Hualapais and Chemehuevis, a Colorado River tribe. Perhaps most notable was his image of a pair of Navajo girls herding sheep in the snow near Rainbow Lodge. That photograph was featured on the cover of the December 1946 issue of Arizona Highways, an issue that became the first nationally circulated consumer magazine to be published in all color, from cover to cover.

Barry was drawn to the Native people of Arizona, but he didn't merely parachute onto tribal lands, then leave once he found the photographs he was seeking. As historian Evelyn S. Cooper wrote in *The Eyes of His Soul: The*

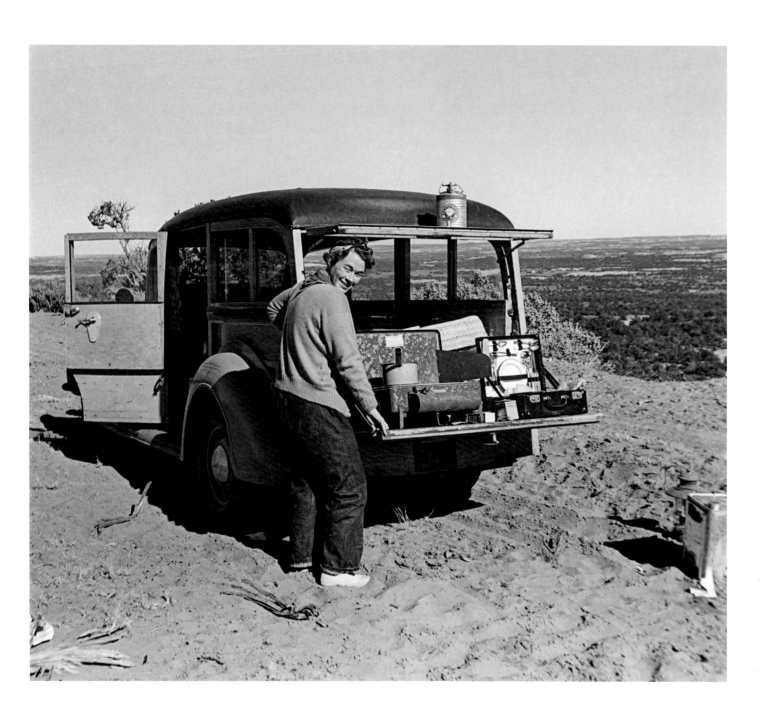

Peggy Goldwater (pictured) and the family would explore Arizona
in a panel truck they used for camping trips around the state.

Visual Legacy of Barry M. Goldwater, Master Photographer: "The knowledge behind their evident magic took a lifetime to acquire." Barry took an ongoing interest in the communities. After a major snowstorm in 1947, he airlifted medicine and food to the Hopi mesas, and he would fly in from Phoenix to help after hearing of emergencies over his shortwave radio.

"He ate Indian food, hunted by their methods, slept in their homes, honored their traditions and showed them the respect of learning words from their languages," Cooper wrote. "More than pretty photographs, he created intimate portraits of people, practices and rituals, many of which were fast falling through the hourglass of history."

And when all else failed, he paid the going rate of $1 to shoot someone's portrait.

There were complexities in his relations with Arizona's Native Americans, especially after Barry became senator and advocated for the Hopis in a series of ongoing land disputes with the Navajos. Barry had also belonged to the Smoki People, a group of non-Indian men in Prescott who would dress as Native Americans and perform sacred ceremonial dances. The members, including Barry, saw the group's activities as a way to honor and preserve traditions by giving the public a chance to witness rituals that would otherwise be off-limits to outsiders.

But many Hopis considered the Smokis' performances to be sacrilegious. And good intentions notwithstanding, in the age of social media, a photograph from that time of a wig-wearing senator performing a dance, his body painted red and clad in a traditional costume, would be the stuff of a political consultant's nightmares.

During the 1940 trip through the Grand Canyon, Barry kept a diary, maintaining a log of weather and river flows and recording his impressions: "Hot as hell, 110°; no shade, no clouds. ... Hottest day yet, 120°. ... God-awful hot."

Barry's nearly seven-week journey had much more in common with one of John Wesley Powell's expeditions than with today's pampered, catered Canyon outings in motorized pontoon rafts. Barry's group wrecked boats, flipped boats and hauled boats off the rocks. They soaked their gear and battled sun, wind, water, sand and bugs along the way.

At times, Barry sounds absolutely miserable, even while his sense of humor remains intact: "Last night was one of those nights when God makes up his mind. He is going to be mean about it. First we were afflicted with swarms of damned May flies. They live only about twenty-four hours, but that is too long. ... A breeze came up and blew them away; then the breezes turned into a gale, and before you could wink, we were almost blown away. Sand swirled in copious quantities; and my ears, mouth and eyes soon were filled with grit."

You also get the sense that he didn't want to be anywhere else in the world. Barry made photographs of clouds billowing high over the ramparts of Marble Canyon, and below Lava Falls, he captured fluted granite walls that look like wax melting into the Colorado. Near Marble Canyon Lodge, he left the river to photograph a Navajo woman weaving a rug while her daughters carded and spun wool.

Upon first crossing into Arizona from Utah, Barry wrote, "I noticed immediately a more bracing quality in the air; a clearer, bluer sky; a more buoyant note in the song of the birds; a snap and sparkle in the air that only Arizona air has, and I said to myself, without reference to a map, that we were now home."

Barry kept the oars from the trip and soon put together a 29-minute color film of the journey. By plane and automobile, he barnstormed Arizona to screen the movie and

Barry Goldwater looks out from Hunts Mesa at Monument Valley in 1968.
JAY TAYLOR

26

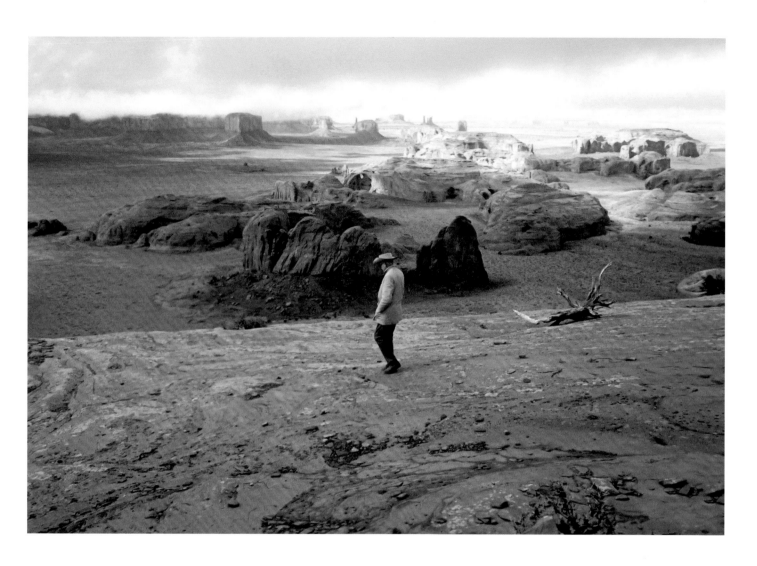

In the aftermath of his loss in the 1964 presidential race and his departure from the Senate, Barry found solace in the land that he once likened to 114,000 square miles of heaven that God had brought down to Earth. At a post-election press conference, he declared, "I've got heaven to come home to. Not everybody has."

deliver a lecture without notes. With showings from Window Rock to Parker, he figured he covered 4,330 miles in the state.

"What better way is there to see Arizona than by traveling around to towns like these?" Barry explained. "The long quiet desert between Phoenix and Yuma, the green fields on the way to Tucson, the rolling hills to Wickenburg, and the mountains on the way to Prescott and Window Rock ... all of these things have been the reward for the work it has taken to give the show."

The Arizona Republic wrote that Barry "told in simple and unhurried style the thrills, chills and spills of that experience." The Casa Grande Dispatch touted him as a "daring amateur adventurer and sportsman" and the film as "one of the outstanding hits of the year," thanks to its "color pictures of the swirling gorges of the Colorado River and the color fantasies of its dizzy walls, along with a narrative of the adventures and experiences of the daring group of half a dozen men and two women."

By April 1941, Barry estimated that, at a time when Arizona had a population of just 499,000, audiences totaling 20,000 had attended 52 showings. That's 4 percent of the population — the rough equivalent of 280,000 people in today's Arizona.

Barry was already a prominent businessman thanks to his family's department store, but the screenings further raised his profile and helped him define what might now be called his "personal brand" in a time long before television and social media. That wasn't his intent. But Barry enjoyed unmatched name recognition across Arizona, and in 1952, after launching his political career on the Phoenix City Council, he made the leap to the United States Senate.

As a senator, Barry's love of Arizona's unspoiled places sometimes conflicted with his belief in free enterprise and what he saw as his responsibilities to his constituents. In 1957, he introduced legislation to expand Grand Canyon National Park, but he also voted against the Wilderness Act of 1964. He pushed for wilderness designation for Aravaipa Canyon, and while out of the Senate for four years after his 1964 presidential loss, he fought to protect Camelback Mountain from rampant development.

Despite often saying that if he had a mistress, it would be the Grand Canyon, Barry advocated for the construction of Glen Canyon Dam, which inundated vast areas he had explored on his 1940 trip. The dam not only changed the rafting experience, but also altered the flow and composition of the Colorado River and the ecology of the Canyon's depths.

Barry was a major booster of federal reclamation projects. For many years, he believed Lake Powell was the most beautiful lake in the world and lauded the visitor opportunities and economic growth it created. But from the ground and from the air, Barry couldn't miss the changes that came to Arizona as the state grew: "While I am a great believer in the free competitive enterprise system and all that it entails, I am an even stronger believer in the right of our people to live in a clean and pollution-free environment."

After observing the impacts of visitors to Lake Powell, he lamented that "we are destroying one of the most delightful places in the world." By 1976, Barry concluded that his vote for the dam was the most regrettable decision of his political career. As he said in a 1994 oral-history interview with Grand Canyon River Guides, "I started out in favor of the dams; I wound up opposed to them."

He was not without his contradictions, this man who wrote of the Grand Canyon in the deepest spiritual terms, yet reveled in the memory of arranging for five F-100 Super Sabre jets to fly over the Canyon and set off sonic booms to challenge reports that supersonic aircraft were touching off landslides: "So they came roaring down that canyon, ba-boom, boom, boom, boom! Not one pebble moved."

In 1993, five years before his death, Barry was asked in a CNN interview how he would want others to remember him. He replied, "As an honest man who tried his damnedest."

THE ROYAL PRINTS

Barry Goldwater was an associate member of the
Royal Photographic Society of Great Britain,
and he often signed his prints with that credential.
We know this because we have some of those prints
in our vault — yes, we have a vault.

BY ROBERT STIEVE
PHOTOGRAPHS BY BARRY M. GOLDWATER

In 1969, Barry Goldwater gave Raymond Carlson a Christmas gift. It was an 11x14 color print of Monument Valley. The photograph was made by Barry Goldwater, and the signed print would become one of our longtime editor's most cherished possessions.

The two men were good friends and colleagues. They'd met, by chance, in the late 1930s at the opening of the old Arizona Brewing Co. in Phoenix. Knowing that Barry spent a lot of time exploring Arizona, Mr. Carlson asked the would-be senator about contributing to the magazine. "The first photograph I sold to *Arizona Highways* was in 1939," Barry said. "Ray and I were driving along one day by Coal Mine Canyon up near Tuba City. Ray said, 'You wouldn't have a picture of that, would you?' I said, 'Yeah, I've got a good one.' I sent it in and he ran it."

The image ran on page 16 in our August 1939 issue.

In the decades since, we've published hundreds of Barry's photographs, many of which were made into prints that are now protected in our vault — yes, we have a vault. When we were putting together our December 2018 issue, Jeff Kida and I went in there to look around. Jeff's our photo editor, and he's stationed in front of the vault like the Queen's Guard at Buckingham Palace.

No one knows the history of the Goldwater prints, or how they ended up in our vault, but it's an impressive collection that includes some photographs we'd never seen before. For that December issue, and also for this book, we opened the vault to share a few of our favorites.

For the sake of integrity, we've presented the prints exactly as we found them, which means you'll see some imperfections. You'll also see the letters A.R.P.S. after Barry's signature on some of the prints. They're an acronym for "Associate of the Royal Photographic Society," which was founded in London in 1853 to promote the budding art form of photography. Barry was admitted as an associate member of the Royal Photographic Society on July 14, 1941, and was a lifetime member of the Photographic Society of America.

Here at *Arizona Highways*, he's a member, too — a beloved family member. As Editor Joseph Stacey wrote in our April 1972 issue: "Barry M. Goldwater is someone special to different people. As a humanitarian and philanthropist, his many private charities are known only to Goldwater, God and the grateful recipients. He is a special friend to the 'little man' and is endlessly involved in significant actions to benefit minority groups of all races, color and creed. To Raymond Carlson and all of us at Arizona Highways, we feel that he is one of us."

So many decades later, that feeling is as strong as ever. Thus, the vault. And thus, this book.

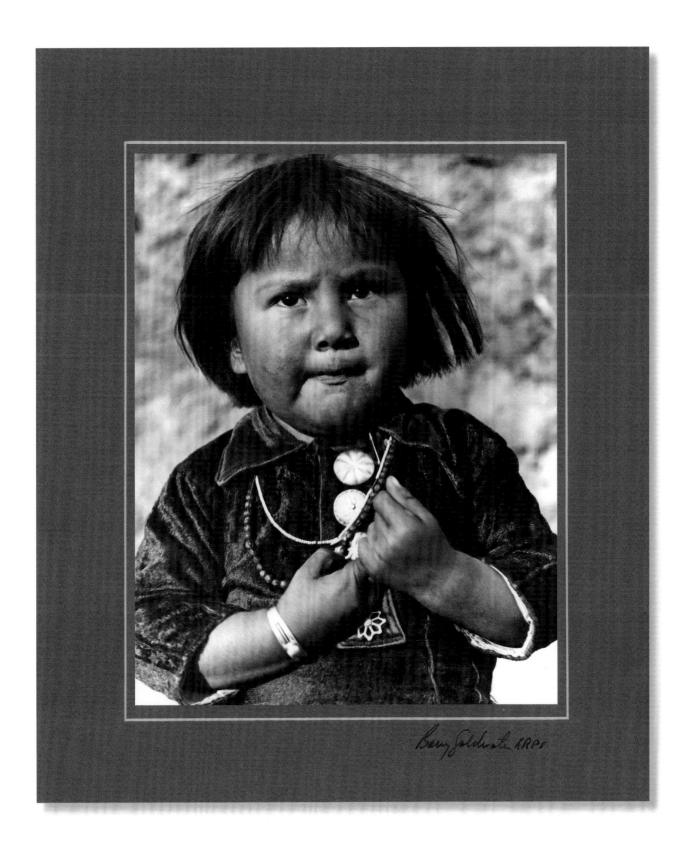

Barry Goldwater FRPS

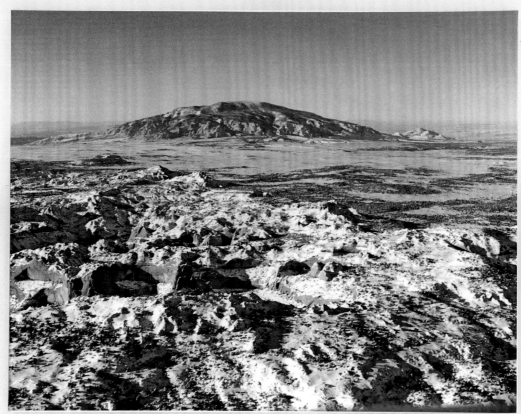

Barry Goldwater

Navajo Mountain from the Arizona side in
the winter with part of Navajo Canyon in
the foreground.

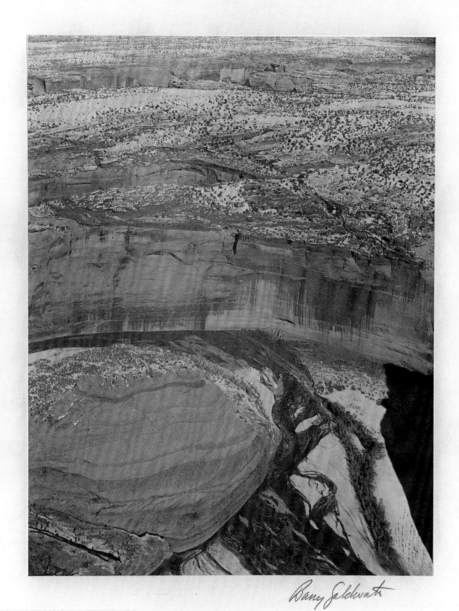

Barry Goldwater

Canyon de Chelly and, if you will look
closely, you can see White House Ruins
at the base of the cliff about the center
of the picture.

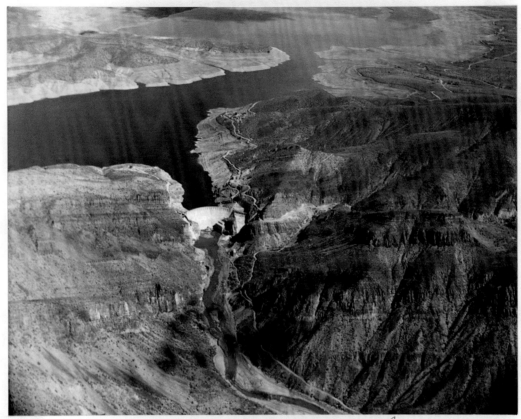

Barry Goldwater

Theodore Roosevelt Dam in Gila County east of Phoenix. The first name for this Dam was Tonto Dam, but when Theodore Roosevelt dedicated the Dam on March 18, 1911, the name was changed to carry his. This was the first major Dam constructed under the Reclamation Act. It is 284 feet high, its base is 184 feet thick and the Lake is 23 miles long.

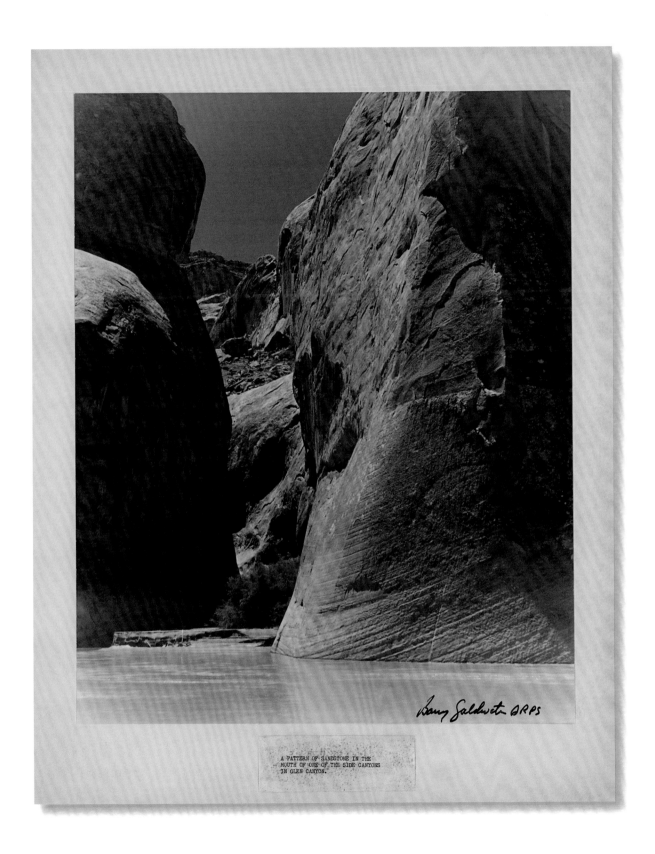

Barry Caldwell ARPS

A PATTERN OF SANDSTONE IN THE
MOUTH OF ONE OF THE SIDE CANYONS
IN GLEN CANYON.

Photographs by

BARRY M. GOLDWATER

THE ARIZONA HIGHWAYS COLLECTION

A Portfolio Edited by ROBERT STIEVE
and ALISON GOLDWATER ROSS

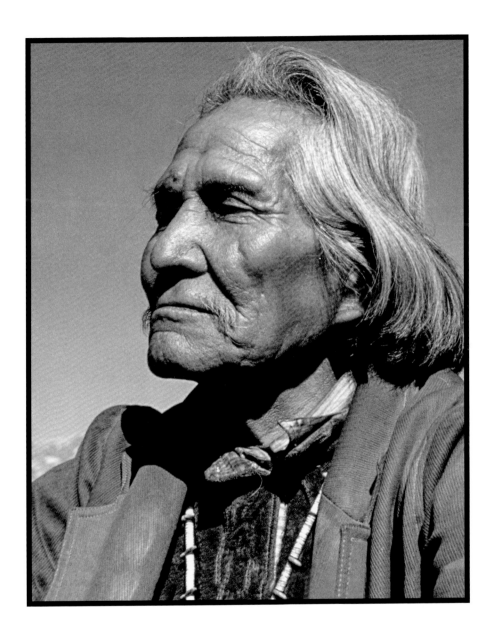

George Avey, *Arizona Highways'* longtime art director, would sometimes work with Barry by cropping his photographs and printing them in black and white. This image, which first appeared on page 9 of our June 1940 issue, is one of them. "That's one of my better pictures," Barry said. "That was taken back in 1938 at an Indian fair near Window Rock. That's an old Navajo. His name is Charlie Potato, and I guess I must have printed maybe 5,000 of those and sold them and given them away. I have it in color and in black and white. I don't speak Navajo, and he didn't speak English. So he was just sitting there, and I just picked the camera up and took the picture, gave him a cigarette and that was the deal."

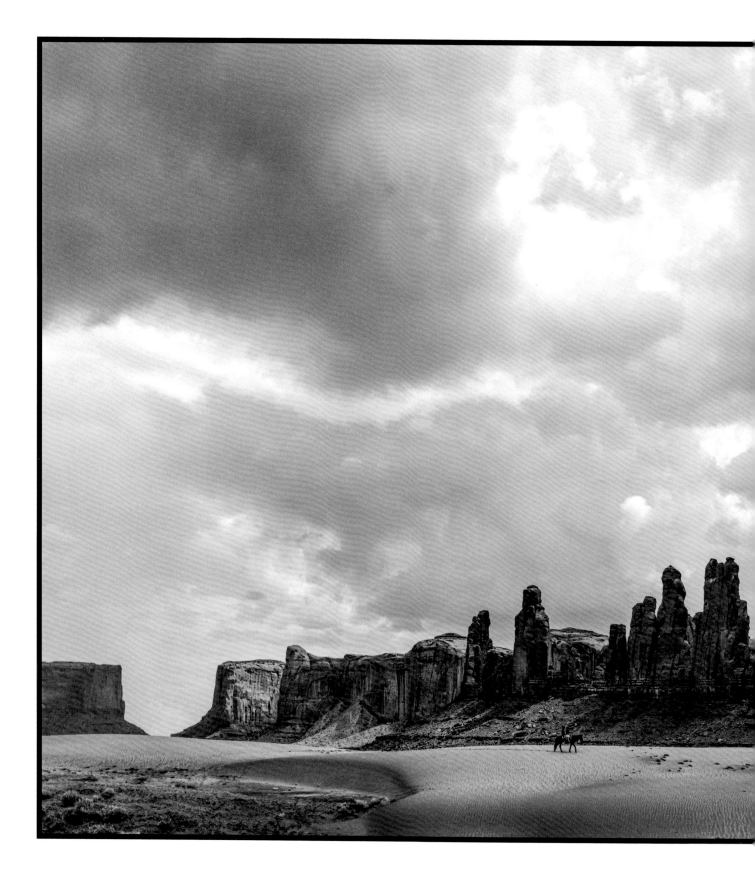

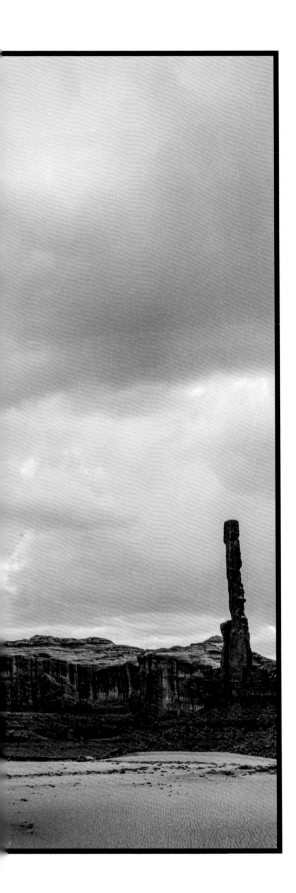

"You get frustrated all the time," Barry said. "You always think, *That ought to be a good picture.* You develop it and find that the exposure wasn't exactly the way it should be. But with black and whites, you can compensate for that." It's impossible to know how much, if any, compensation was necessary for this image, which is titled *Totem Pole & Yei Bichei, 1967*, but the final product ranks as one of the most impressive photographs in the photographer's extensive archive.

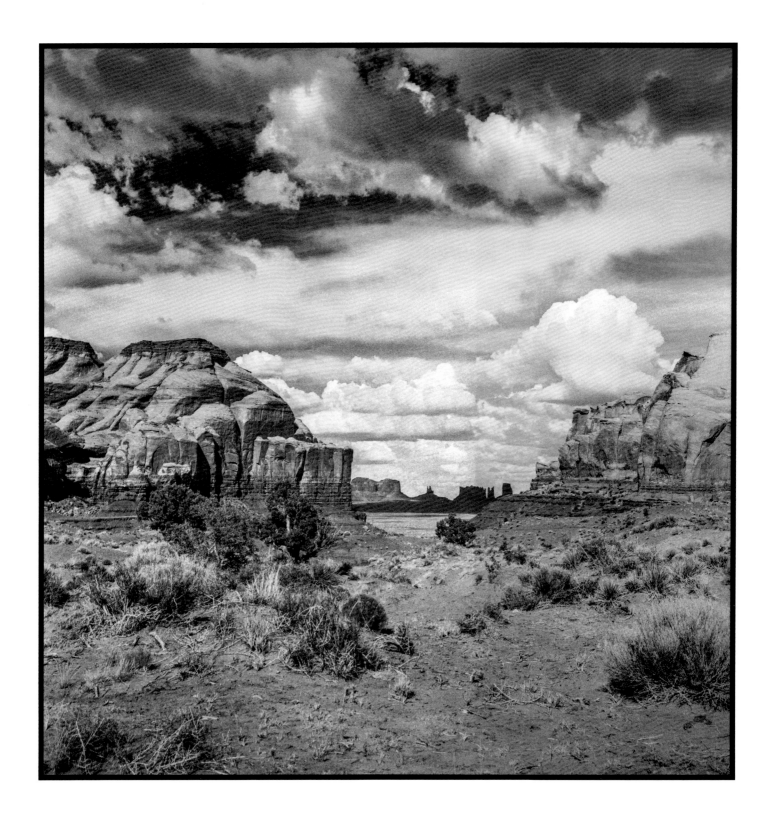

"Barry Goldwater created some really wonderful work. It's a testament to his love of Arizona and its people. To be photographing during his time, and in so many of the same locations — especially Monument Valley — was a real treat for me. He was very influential, encouraging and special to me so early in my career."

— DAVID MUENCH, *photographer*

This is a photograph from the family archive titled *Valley of the Monuments*. It was made in 1967, and it epitomizes Barry's affection for his homeland: "Someone once remarked that 'beauty is in the eye of the beholder,' and there is no horizon to my vision of Arizona's beauty. My feelings about Arizona are mingled with love: love of people, love of the land, love of country."

"The Navajo reservation is a fascinating place to visit," Barry said, "not only for the lessons it teaches about the Navajo's way of life, but also for the splendor of its high desert terrain and for the traces that remain of ancient Indian civilizations." This photograph, which Barry titled *Navajo Maidens Working*, offers a glimpse of that. "I call the girl on the right the spinner," Barry said, "because she has a spinning wheel in her hand. She spins the raw wool into threads the other girl will use to make the rug with."

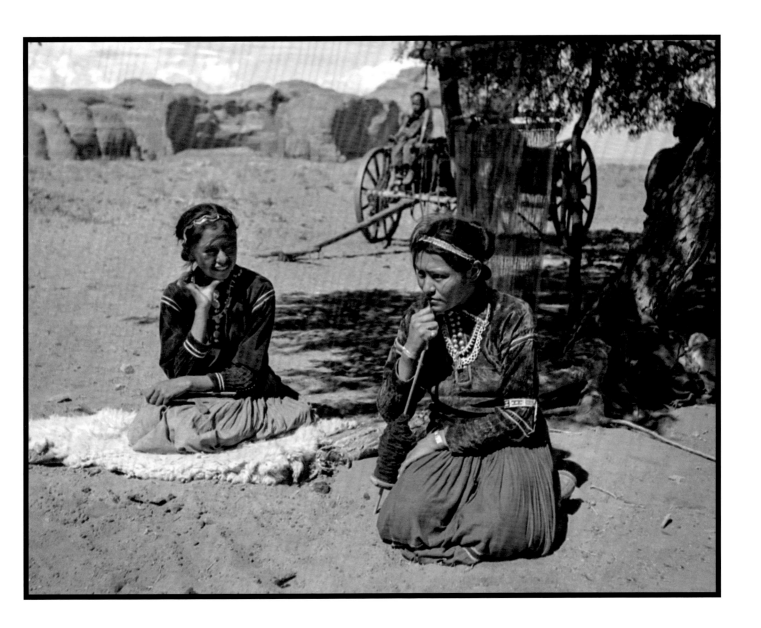

"I don't necessarily use a lot of lenses," Barry said. "For portrait work ... I like to use a 200 mm, because I can get away from the person and get the face without too much background trouble." In his book *The Eyes of His Soul*, Barry's son Michael explained that most of his father's portrait work was focused on the Hopis and the Navajos. "He respected their ways and customs to the extent that he made a deliberate effort to record their historic transition to modernity, often with mixed emotions," Michael wrote.

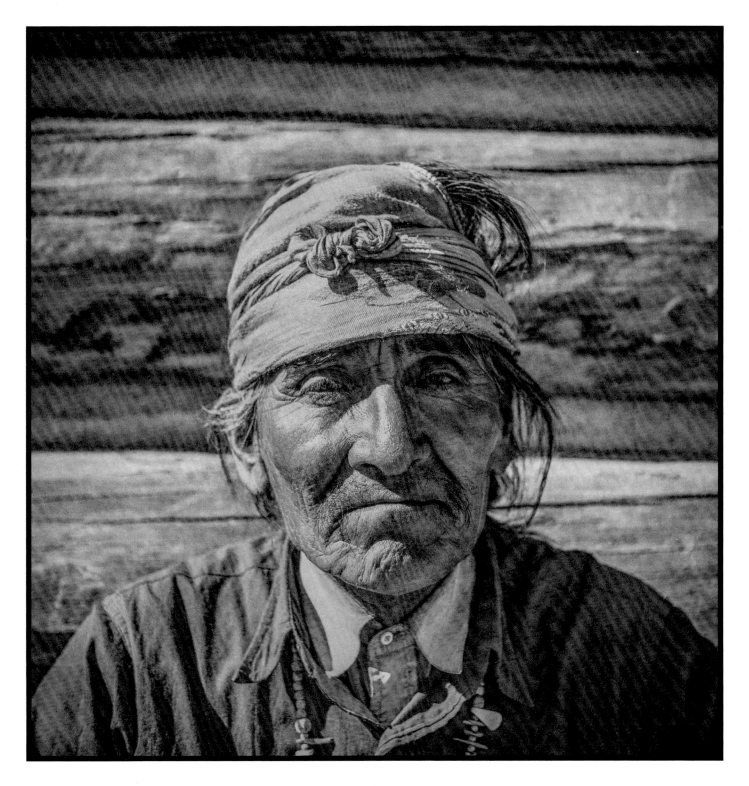

"Many years ago, I was at the head of the Rainbow Bridge trail, southwest of Navajo Mountain, preparing to take the long hike down the rugged canyon route to the great natural bridge near the Colorado River. There I met a young man who was obviously pursuing photography, as I was, and with obvious fervor. He introduced himself as Barry Goldwater of Phoenix."

— ANSEL ADAMS, *photographer*

This photograph, titled *The Rainbow*, was published in our June 1946 issue. The natural landmark had special meaning for Barry, both personally and professionally: "Edward Weston and Ansel Adams were about the best photographers we ever had," Barry said. "Ansel and I were friends. The first time we met was up on the Navajo Indian Reservation. He was trying to get down to Rainbow Bridge [pictured], and I was trying to tell him the easiest way to get there. We remained very close throughout his life. I've got quite a few letters from him and a few prints that we swapped."

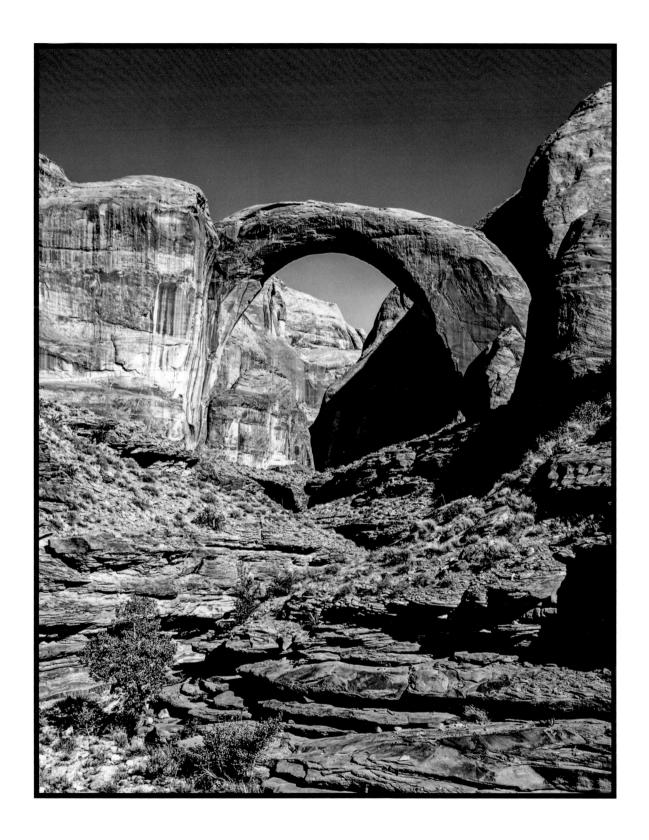

FELIZ NAVIDAD

This is the festive season, the season of family and friends, the season of home and fireside. This is the season when, if we are wanderers in the world, we think of familiar faces and familiar places, and our thoughts travel the intervening miles. The wounds and sorrows of War are fresh and vivid, but as the Yuletide approaches and the New Year comes we enter the season cheered with the hope that our world will be a better and happier place for all. We who are fortunate enough to be living in this blessed land, this rich, strong America, are grateful and humble for the blessings bestowed upon us. Let there be happiness in the land and good cheer!

In keeping with the festive season, *Arizona Highways* appears this month in festive dress. We have tried to make the pages gay and colorful and friendly, because through these pages we in Arizona are saying "Merry Christmas!" to all the world. It may or may not be an achievement, but as far as we know this is the first time in American publishing history that a magazine of general circulation appears completely illustrated from "cover to cover" in color. (That loud "crick" you just heard is a sprained elbow caused by patting ourselves on the back.) If an average of five people reads each copy of this, the December issue of our magazine, 1,125,000 people will be the happy family of *Arizona Highways* for one month at least. Which is quite a gathering of folks!

It was a cold, raw winter day deep in the Navajo Reservation when Barry Goldwater took the picture we use on our cover. The snow clouds were low over Navajo Mountain and the little Navajo girls, watching their sheep, were wrapped in their blankets against the wind. The whole scene is real and simple. You would have found the same simplicity many, many years ago in a place called Galilee.

So we leave you now to our December pages, thanking you for your friendship and good will and wishing you and yours all the good things in life, a Merry Christmas, or as they say south of Nogales, "Feliz Navidad," and a Happy New Year, full of sunshine and good traveling.

— *Editor Raymond Carlson, December 1946*

"The cover of the very first all-color issue *Arizona Highways* published [December 1946] was a picture of mine," Barry said. "Ray [Carlson] asked me to shoot some Navajos in the snow, tending their sheep. This was in late February 1946, and I told him he was out of his head, that it never snowed on the reservation in springtime. So I said I'd try to get something the next year. But as it happened, I was up at the trading post [Rainbow Lodge] near Navajo Mountain the next week, and when I woke up one morning, there was about 2 feet of snow all over everything. So I ran down the road about 3 miles and got my picture. Just what he wanted. But I prefer shooting black and white." Although this is not the exact image that ran on our cover, it's from the same roll of film.

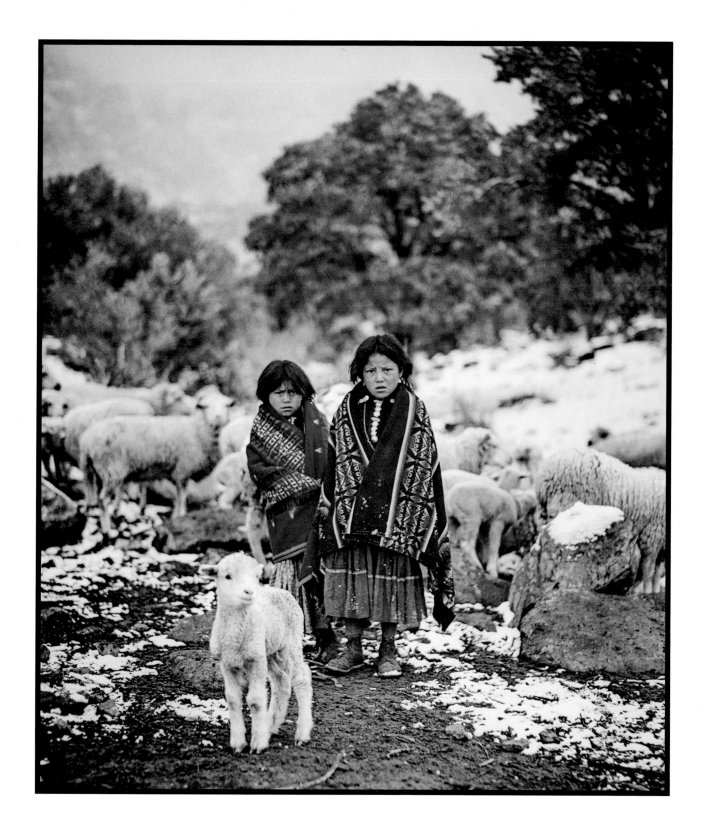

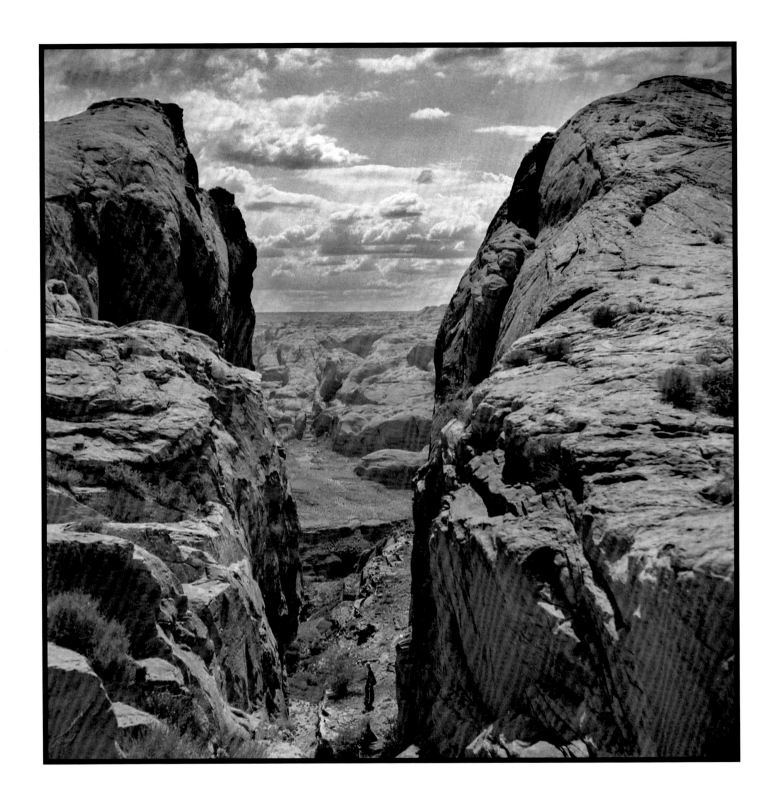

In the late 1800s, the Mormon Church was looking to expand into areas of Utah beyond Salt Lake City. A scouting party, under the direction of Silas S. Smith, left Paragonah, Utah, in April 1879 to determine a route and search for a suitable place to establish the new colony. Ultimately, the party settled on a "shortcut" through what came to be known as Hole-in-the-Rock (pictured). And on January 26, 1880, the expedition — consisting of 250 men, women and children; 83 wagons; and more than 1,000 head of livestock — made its way slowly down the precarious road, which dropped nearly 2,000 feet with an average grade of 25 degrees.

"The canyon [pictured] is short, not over three-quarters of a mile or, at most, a mile to where it tops out. It is most difficult of ascent and descent, even on foot. I spent nearly three hours walking up and down because of my knee and my cameras. On the way down, I slipped and fell about 10 feet, landing on my belly on my camera case. Cursing appropriately, I went on, none the worse for my clumsiness."

— BARRY M. GOLDWATER

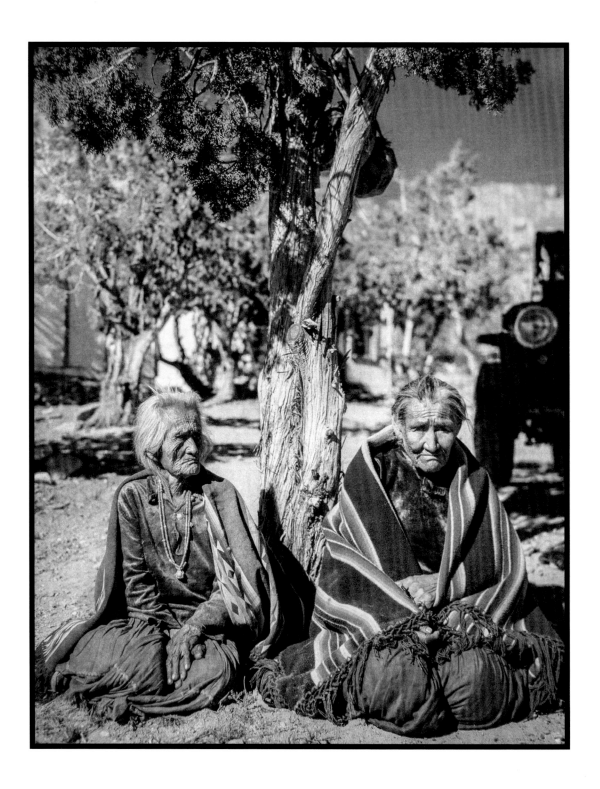

"I'm trying to record the history of my state," Barry said, "so that students, 25, 50, 100 years from now, can find a picture that didn't exist when I started."

This image, which was made in 1959 at Canyon de Chelly, is titled *Navajo Man at Spring*. It ran in our September 2010 issue. "Amid the stark beauty of this desert is one of the most spectacular natural wonders in the world — Canyon de Chelly National Monument," Barry wrote.

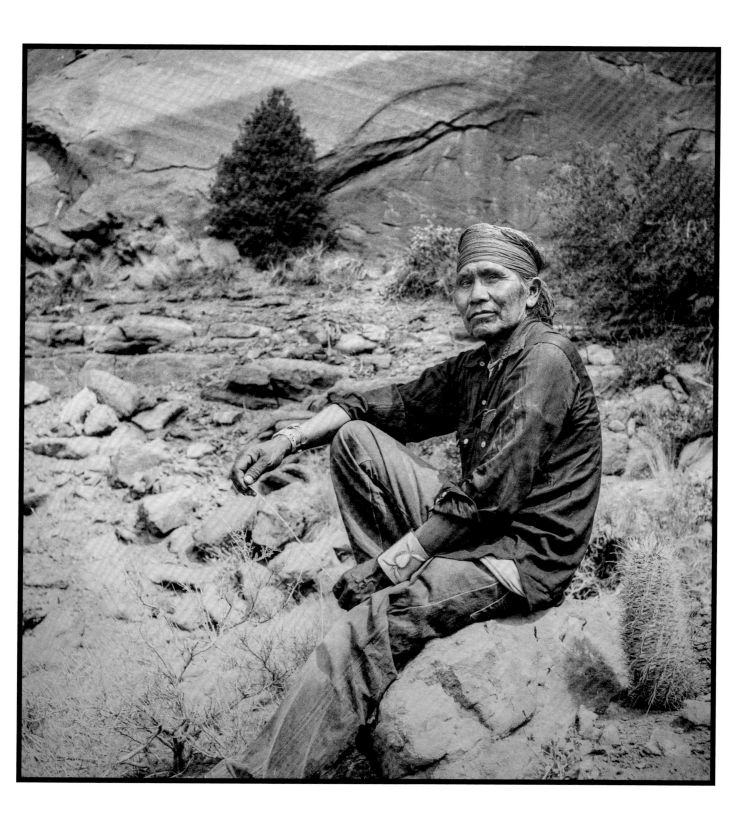

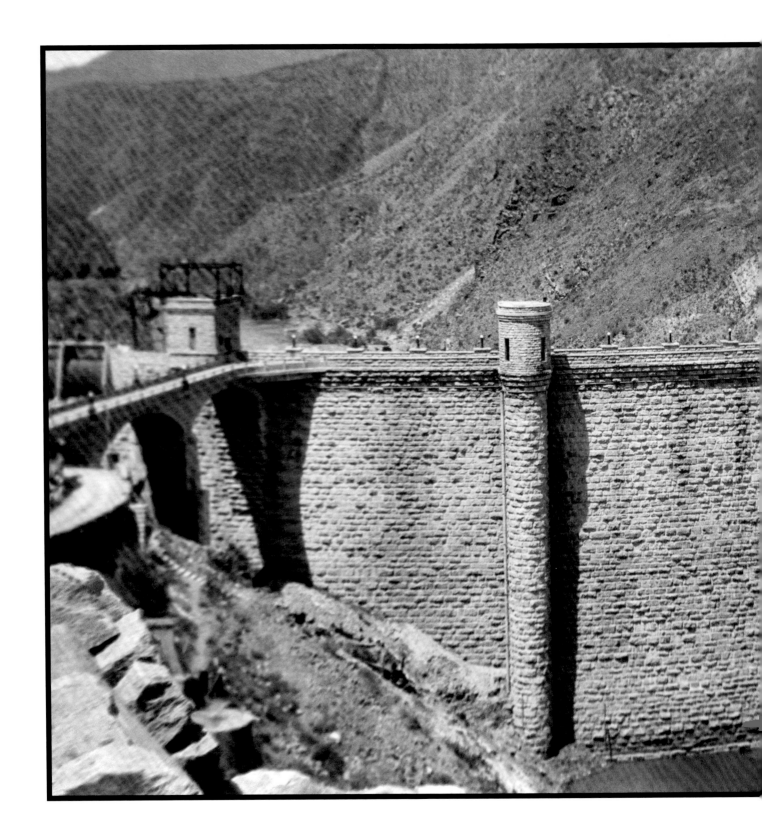

Construction on Theodore Roosevelt Dam began in the early 1900s, when foundations were excavated and a cofferdam built. When it was completed in 1911 — at a cost of $10,166,021.97 — it created Theodore Roosevelt Lake, the largest reservoir located entirely in Arizona. The original dam, shown in this photograph by Barry Goldwater, measured 184 feet thick at the base and 16 feet wide at the crest, rose 280 feet into the air, and spanned 723 feet across the canyon. But as the dam got older, concerns about safety began to take hold. Engineers determined that during a "maximum flood event," the dam would be unable to safely release water to prevent flooding. And if a sizable earthquake were to occur near the dam, it could have failed entirely. For those downstream from the reservoir, the consequences would have been catastrophic. So, from 1989 to 1996, a new concrete-block structure was built around the original dam, raising its height to 357 feet. However, this meant the qualities of the original dam were no longer apparent. As a result, Theodore Roosevelt Dam's National Historic Landmark designation, which was given in 1963, was withdrawn. It's one of only 35 such landmarks in the U.S., and the only one in Arizona, to have its "historic" designation taken away.

"If I ever had a mistress,
it would be the Grand Canyon."

— BARRY M. GOLDWATER

"I first saw the Grand Canyon when I was about 7," Barry wrote. "Two years later, I went down the trail to the river, and since that time I have probably walked down every available trail in the Canyon." He also made several trips down the Colorado River. His first was in 1940. "When a man has an itch for the greater part of his life, there comes a time when scratching is inevitable," he wrote. "This particular itch can be classed as 'riveritis,' and of the particular river causing the itch there could never have been any doubt — it was our Colorado."

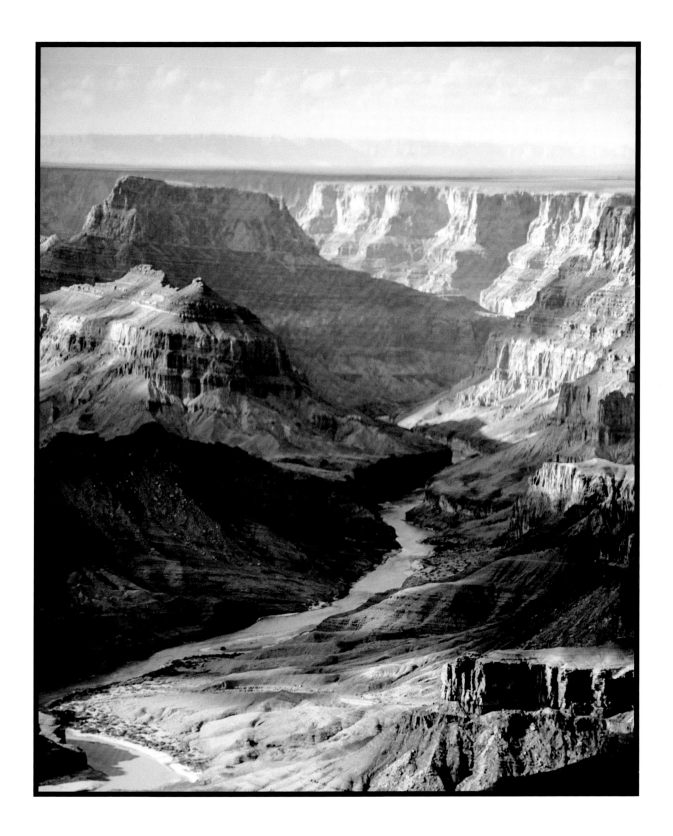

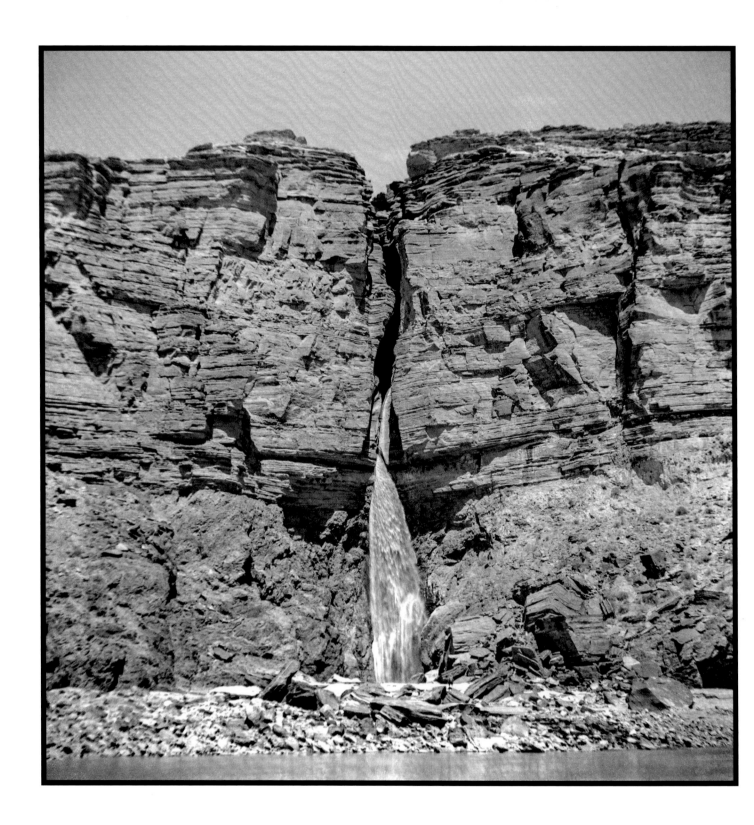

"Just after dinner we pass a stream on the right, which leaps into the Colorado by a direct fall of more than 100 feet, forming a beautiful cascade," John Wesley Powell wrote about Deer Creek Falls in August 1869. "There is a bed of very hard rock above, 30 or 40 feet in thickness, and there are much softer beds below. The hard beds above project many yards beyond the softer, which are washed out, forming a deep cave behind the fall, and the stream pours through a narrow crevice above into a deep pool below. Around on the rocks in the cavelike chamber are set beautiful ferns, with delicate fronds and enameled stalks. But we have little time to spend in admiration; so we go on." Seventy-one years later, Barry would become the 73rd person to run the Green and Colorado rivers. In his diary from the trip in 1940, he wrote: "Deer Creek comes down from the North Rim and winds through a tortuous canyon of the Redwall Limestone along the river where it plunges about a hundred and twenty-five feet to the river level. It is situated about two hundred feet back from the river and shoots sideways out of the crack in the wall. The water assumes a fan shape as it comes down and falls freezingly and forcefully on those who venture below it. We did and were cool for a change."

"The northern stretch of the Indian Country falls within Monument Valley," Barry wrote. "There are many, many things to be seen in the valley, where a person can spend months traveling without doubling back and see something new every hour of the day." When we ran this image in September 2010, we asked Barry's son Michael about his father's attraction to Monument Valley. "Over the years," Michael said, "Dad shot a vast series of frames of the mesas, spires and buttes that rise as much as a mile high out of the majestic valley. This image conveys both his love of the place and his technical precision at maximizing depth of field."

"We sometimes forget that Art, in any form, is a communication. Barry Goldwater has communicated his vision of the Southwest, and he deserves high accolades for his desire to tell us what he feels and believes about his beloved land. In this age of random thrust and confused directions, it is good to know that there are such dedicated people with ideas and objectives. May their tribe increase!"

— ANSEL ADAMS, *photographer*

"To attempt to show adequately the beauties of Arizona, either by pictures or by words, has always seemed to me a task too great for man," Barry said. "Neither the lens nor the written word can show the history or the romance that adds so much to the beauties with which this state has been endowed." Two of Barry's favorite subjects were Agathla Peak (below) and Church Rock (right).

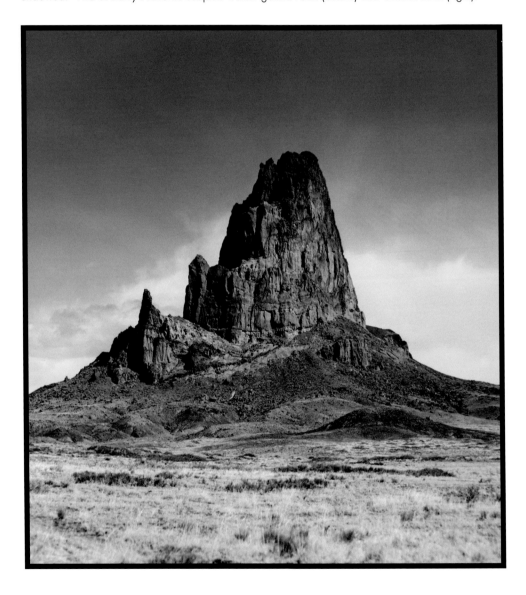

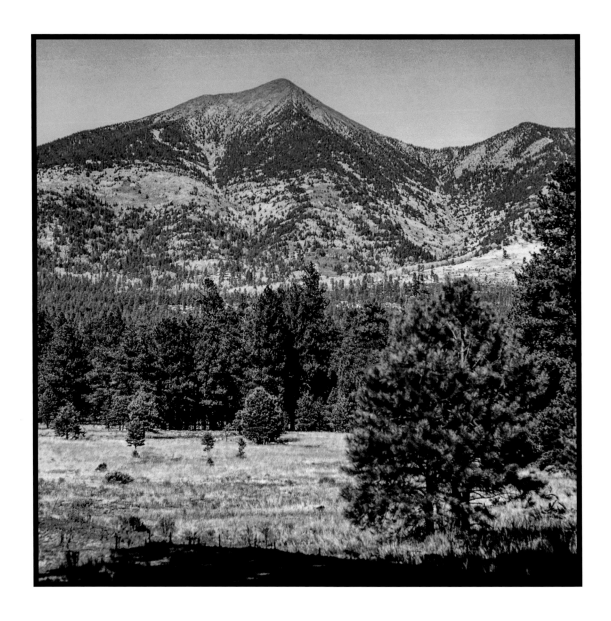

"Flagstaff's chief natural attraction, which can be seen from many places in Arizona, is San Francisco Mountain to the north," Barry wrote. "Because it has three separate peaks — Agassiz Peak, Fremont Peak and Humphreys Peak — San Francisco Mountain is commonly referred to as the San Francisco Peaks."

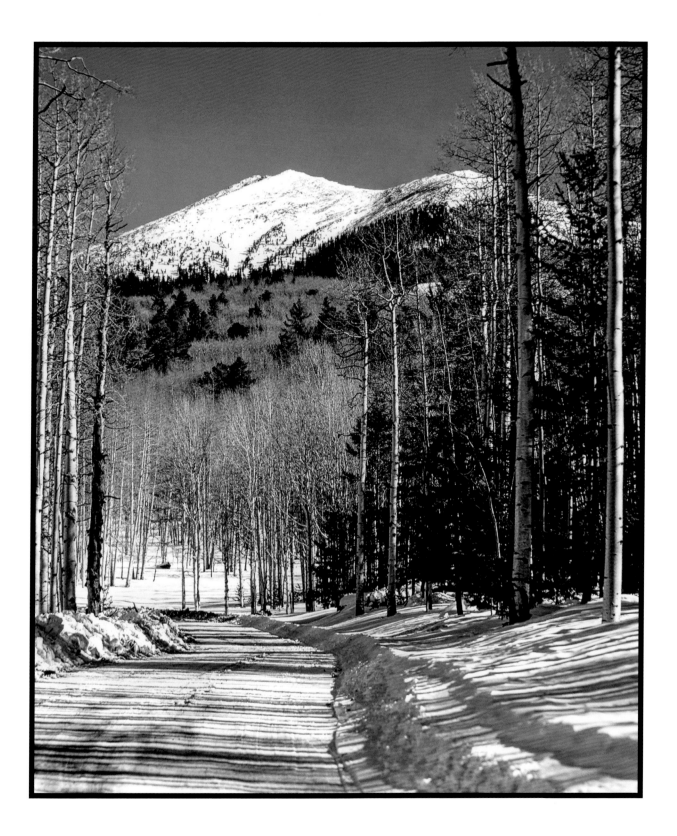

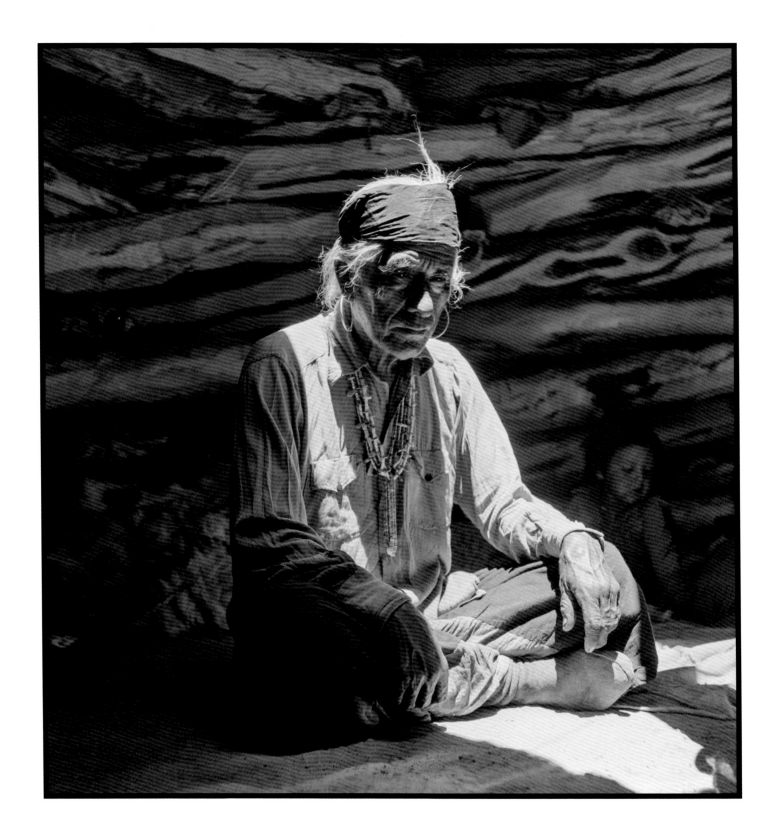

"This is a Navajo who lived up in the Paiute country," Barry said. "This is one of my favorite pictures. I just call it *The Chief*." The man's given name was Dug-ai, and this image of him was featured in our July 1952 issue, in a piece titled *Land of the People*. The caption read: "This aged Navajo, who is probably in his 90s, lives on the north side of Navajo Mountain. Once you step into the serene calmness of Dug-ai's hogan, you feel the great dignity and the great wisdom that all the years of calm and just living can bring to any man's home."

"I absolutely love the image of the gentleman sitting in the shaft of sun [*The Chief*]. From a technical perspective, the challenge of getting detail in both the highlights and the shadows was no easy task. This shows that Barry knew his craft. Also, the texture on the log wall background plays perfectly against the subject. Having spent 400 days, over two years, photographing the Navajo people, I understand some of the challenges he faced stepping into a very guarded culture. Beautifully done!"

— JOEL GRIMES, *photographer*

71

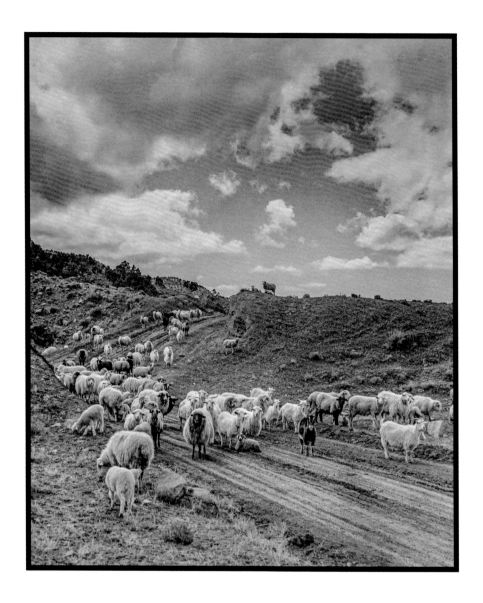

"The roads wander in aimless fashion through the limitless land of the Navajo," Editor Raymond Carlson wrote in the caption for this photograph (above), which ran in color in our August 1946 issue (right). "To keep you company over these roads are lonely Indian hogans, miles of scenery and an occasional flock of sheep. The sheep have the right-of-way." The image, which is titled *The Road*, offers a glimpse of what Mr. Carlson was referring to, and what life was like in the early years of the last century. "The great thing about photography," Barry said, "is that through it, I was able to enjoy my state as it was growing up, and capture some of it on film so other people could have a chance to see it as I knew it." In searching the archives, we couldn't find the color negative for this photograph, but we were able to locate a black and white version. The color image was made from a scan of our August 1946 issue.

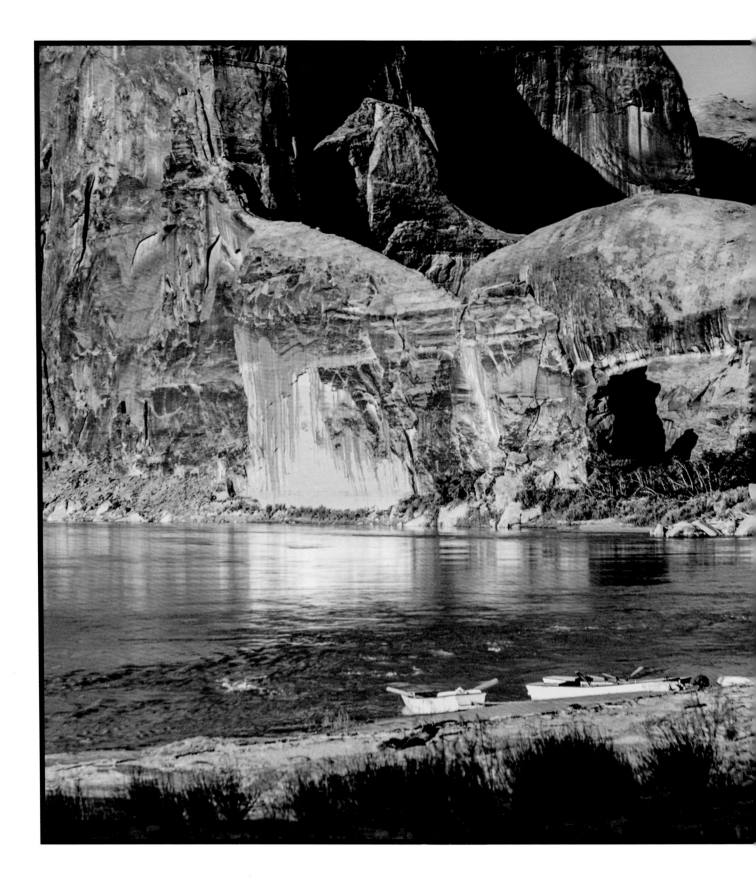

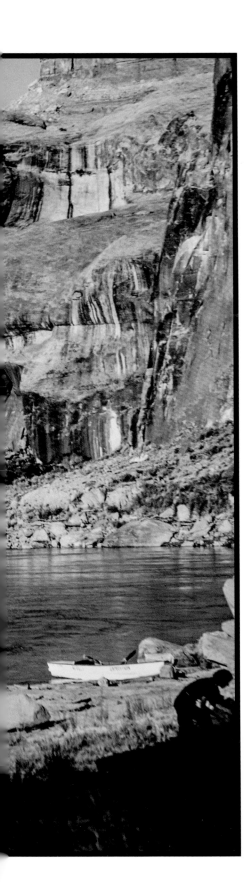

"Outside of the work of the Kolb brothers [Emery and Ells-
 worth] and [Frederick Samuel] Dellenbaugh," Barry said,
 "my collection of pictures from Glen Canyon to the main
 [Grand] Canyon itself is the most complete ever taken.
 I don't like color too much, but I take them."

"After a while, I picked up a large-format view camera, one that you look down into and that takes about a half-hour to wind up. I also used a Rolleiflex, which is what I still use for black and white, and a 35 mm for color."

— BARRY M. GOLDWATER

"His strength, to me, was in his connection to Arizona and its Native people," photographer Paul Markow says. "A couple of times, I have gone out to shoot some of the elders of the Navajo Nation with a friend who had a Navajo trading post. I was never really trusted, even with my chaperone. So, getting that generation of Native Americans, born in the late 19th or early 20th century, to trust you is one of the hardest things to accomplish in photography. Barry was able to record a rapidly receding culture of non-Anglo-influenced Native Americans and leave behind his wonderful visual record of that time and place."

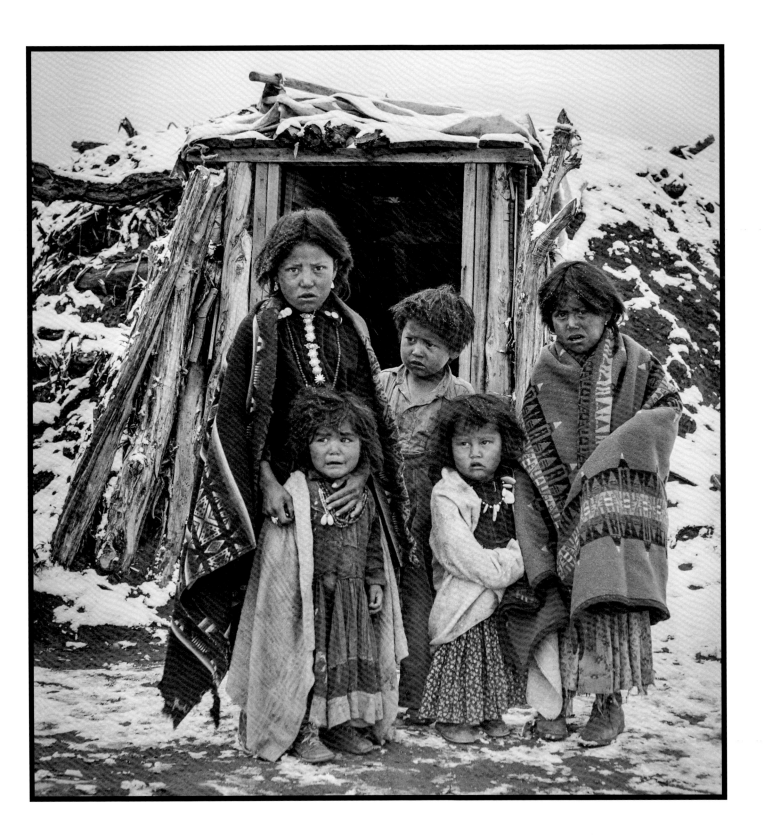

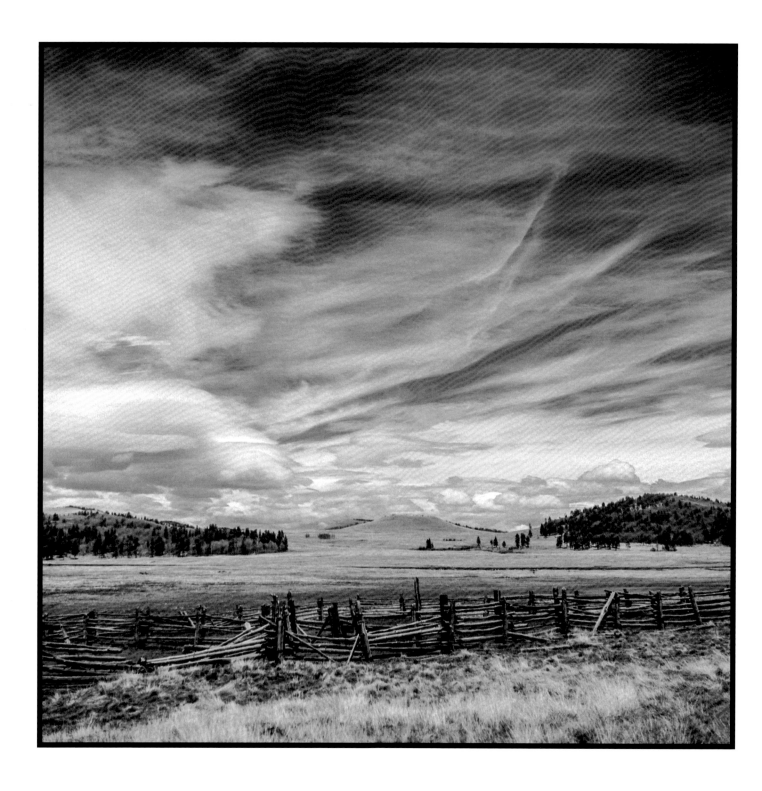

"To photograph and record Arizona and its people — particularly its early settlers — was a project to which I could willingly devote my life, so that I could leave behind an indexed library of negatives and prints to those who follow."

— BARRY M. GOLDWATER

"A good friend of mine described Arizona as the 'Big Country,'" Barry said. "This piece of the 'Big Country' is between the lumber town of McNary and the sportsman's center, Springerville. The hill in the distance is an extinct volcanic cone, one of many that dot this White Mountains area, reminding us that out of the violence of evolution has come the quiet beauty which is ours." This image, which was made in 1953, ran in our September 2010 issue.

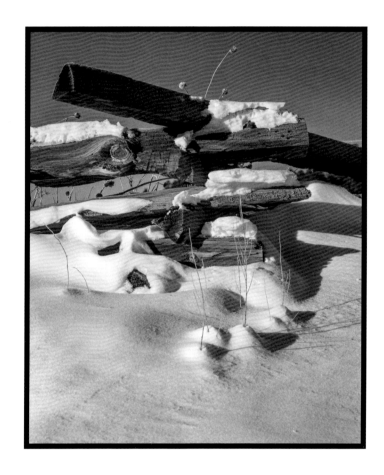

"Many people who have never been to Arizona think of it as only a land of desert," Barry said. "Yet, two-thirds of our state is covered with forest. In fact, the largest stand of ponderosa pine in the world is in Arizona. When the snow falls, the northern portion of our state becomes a veritable winter wonderland."

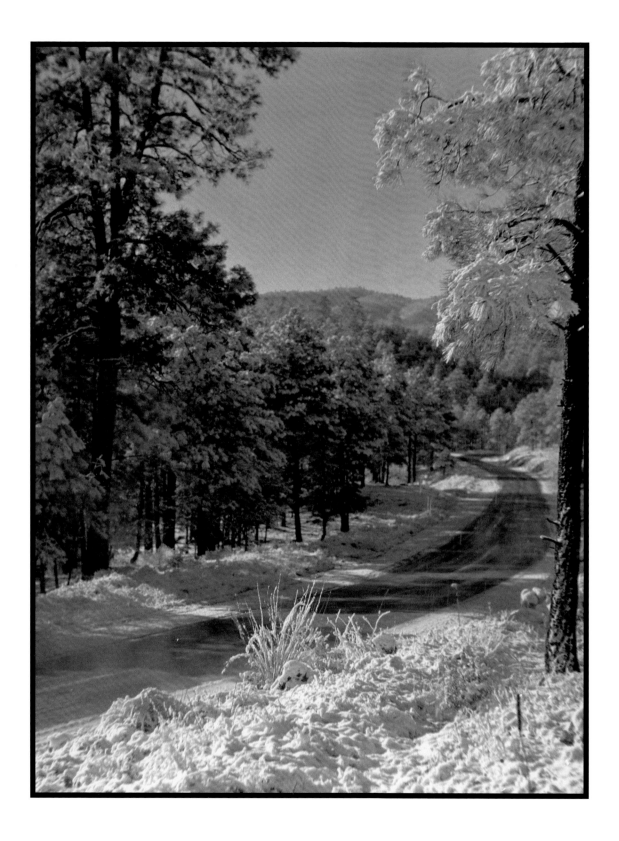

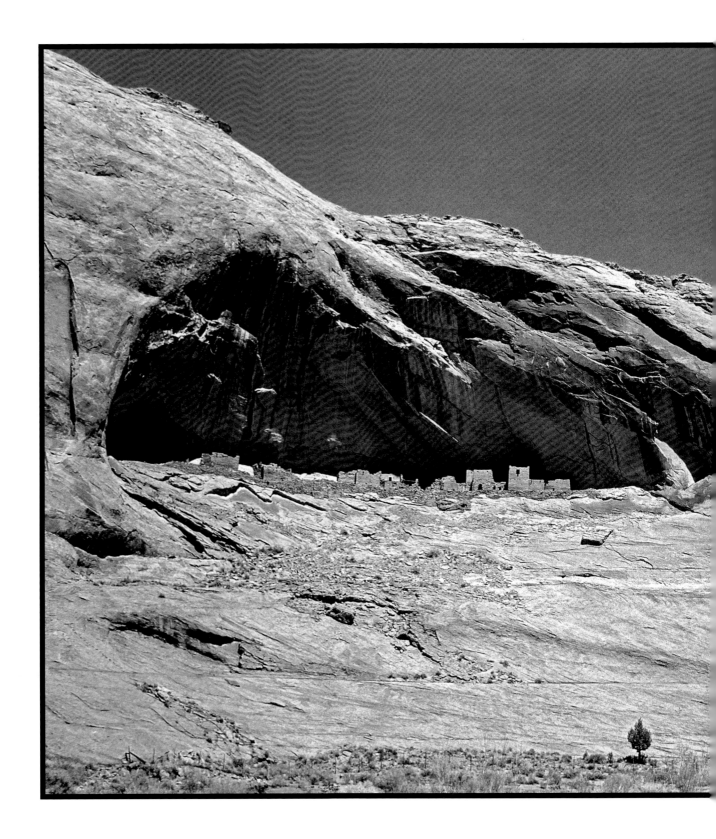

In August 1968, we published this photograph. The caption read: "Inscription House is a majestic sight in its oval-shaped cave high on the cliff." That same year, the National Park Service closed the ruins to public access. "Although limited visitation takes place at Betatakin and Keet Seel, visitation damage to the extremely fragile Inscription House cannot be mitigated," an NPS statement reads. A decade earlier, however, Barry, who also was a gifted writer, penned a piece about the ancient ruins. "Navajo Monument," he wrote, "that great area of the Navajo country in Northern Arizona which contains three of our greatest cliff ruins, is seldom visited in its entirety because of the distances between the ruins and because of the misconception concerning the ease with which it may be done. Let's just take Inscription House for an example. Here is a great ruin located just a few miles off of a road that, while bumpy now and then, is perfectly passable, but you can number on a few hands the people who visit this place each year. It is plainly marked on the maps, but the person motoring to Rainbow Lodge just drives on past, ignoring one more wonder left by the ancients for him to see."

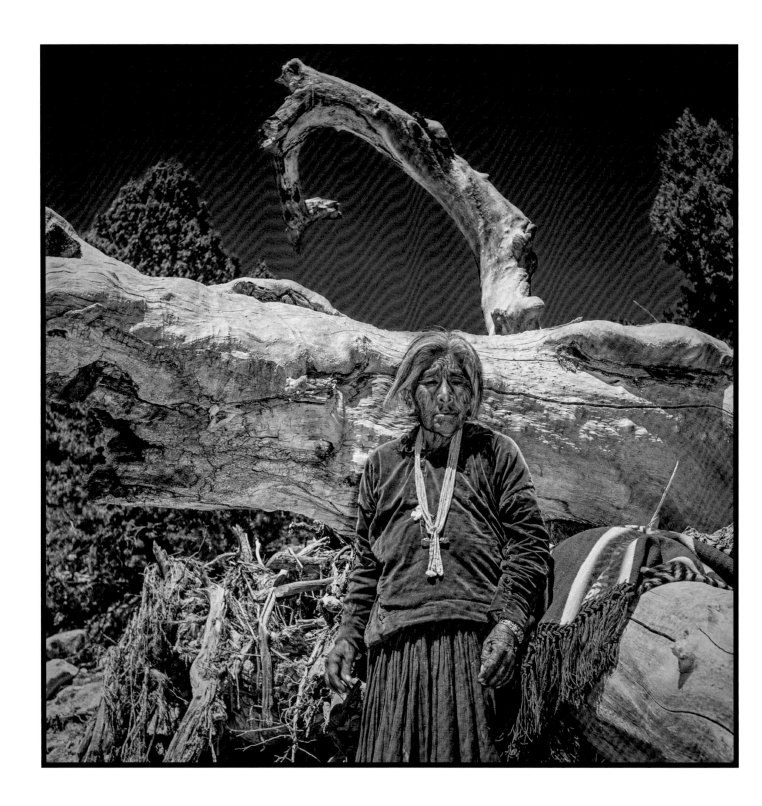

"Black and white photography gives the photographer the opportunity to tone the picture," Barry said. "He can bring out the darks, he can bring out the light shades, or he can mix them up. He can compose by moving the paper around or moving the enlarger around until he gets just what he wants." In addition to the other inherent challenges, the woman in this image, titled *The Old One*, proved to be a reluctant subject, Barry said.

"I've shot a lot of landscapes," Barry said, "but I'm proudest of my Indian photography. I think I've got about as good a recording of the Indians of Arizona as has ever been done — every tribe, and parts of tribes that hardly anyone's ever heard of."

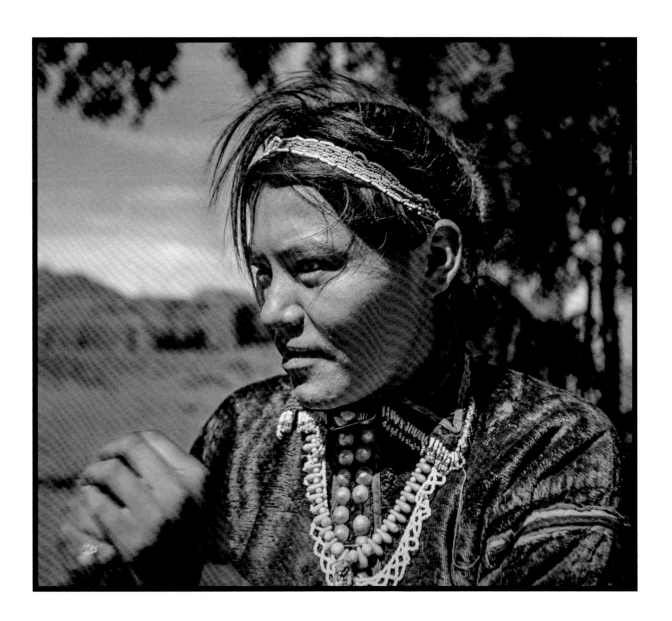

"Dad had an eye for the picturesque," Michael Goldwater says, "whether natural or man-made. He particularly fancied scenes that offered a combination of the two, such as this stunning view of a windmill located near Pipe Springs in the vicinity of Wolf Hole."

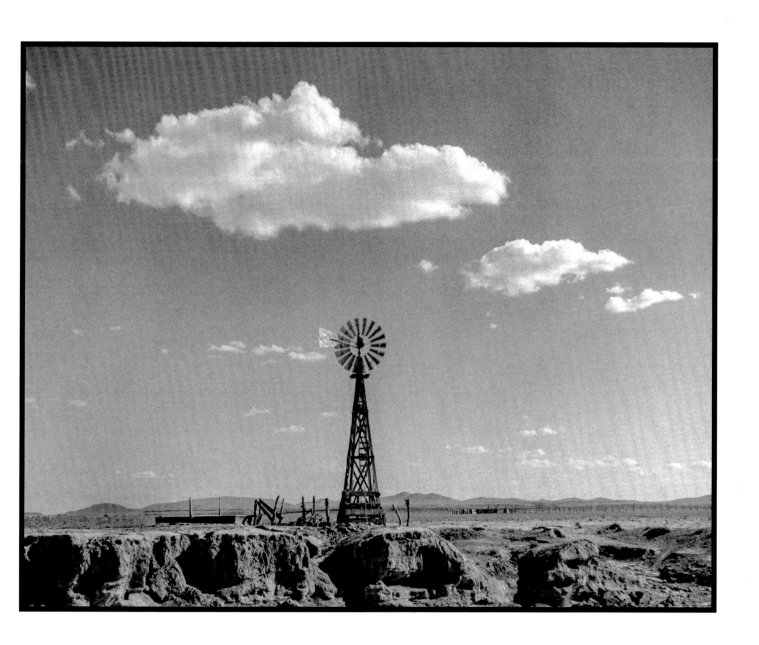

"Saguaros are a very difficult plant to photograph … [but] I like to photograph the flowers," Barry said. "They're a night-blooming flower. They bloom at about 9 o'clock at night, and by noon the next day, they're dead. So you get up early in the morning and just get the crown. And that makes a beautiful picture. But to just take a picture of a saguaro … that's like taking a picture of a tree." Saguaros, he continued, "are a source of food and refuge for some of the animal denizens of the desert. Before they fall, much of the fruit and their seeds are eaten by birds, and the fallen fruit is food for coyotes, peccaries and mule deer. Gila woodpeckers and gilded flickers make nest holes in the stems of the saguaro, and after their young have flown away, the holes are taken over by other species of birds."

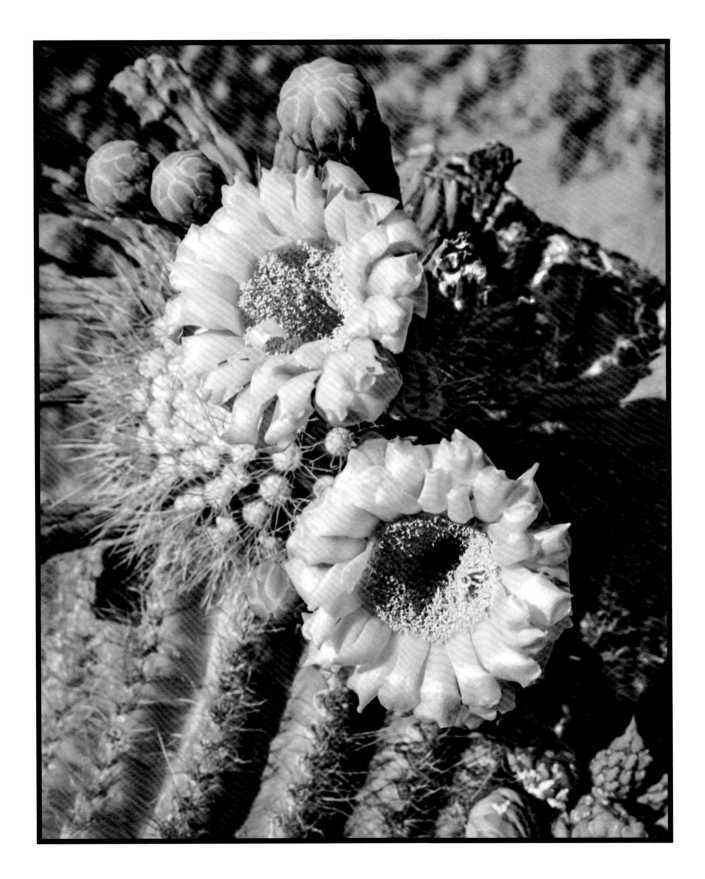

"Edward Weston was
a great photographer whom
I liked to imitate. I think
he was probably the purest
of them all. I found these
old wheels while driving
north of Prescott on the
Old Williamson Valley Road
one day in the late 1930s.
I call it *Westward Ho,* and
it is one of the most popular
photographs I have ever
made. It has been displayed
well over 60 times in various
salons around the world."

— BARRY M. GOLDWATER

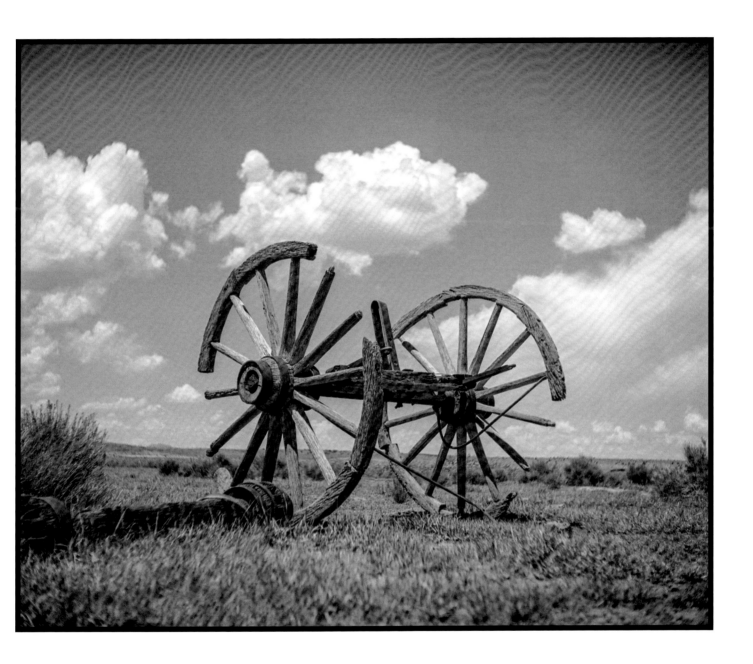

"Barry once said about his photographs: 'They have been taken primarily to record what Arizona looked like during my life.' This is how a lot of us older Arizona nature photographers feel," photographer Paul Gill says. "After witnessing decades of change from drought and other factors, we're recording the beauty of what we see around us through artistic expression for all to see now and in the future. Some of the things that Barry and I have in common: We both started working in large format with the Graflex Crown Graphic press cameras, and we were both influenced by Edward Weston."

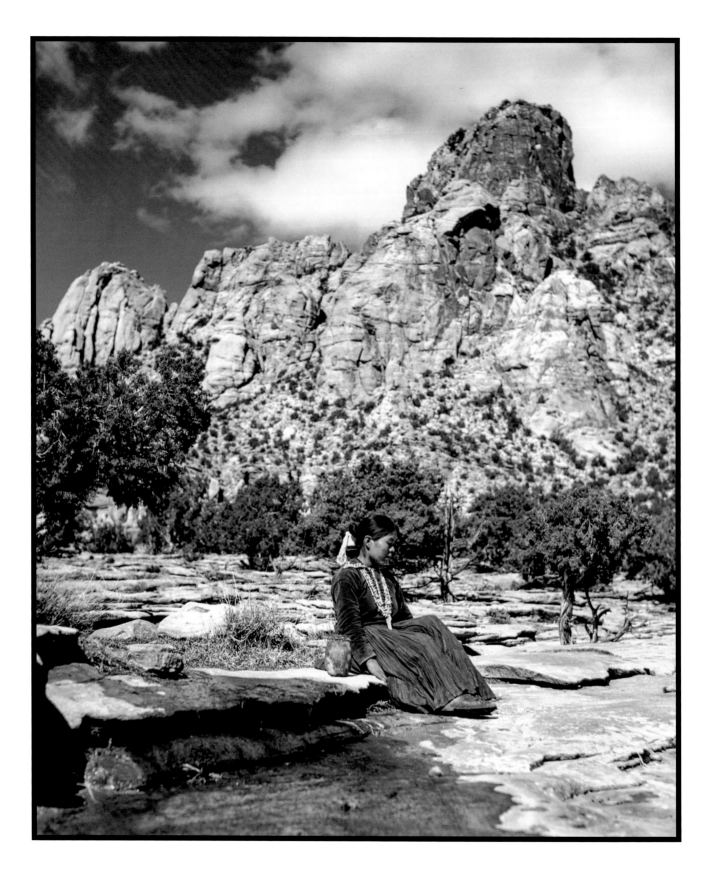

"There are many good courses offered around in different cities in this country that would make certain types of photography easier," Barry said. "Portrait photography is not easy. You have to study that. That involves lighting."

"Indians are no longer superstitious about cameras," Barry said. "They used to be. It was very difficult to get their pictures. Later, they got used to them."

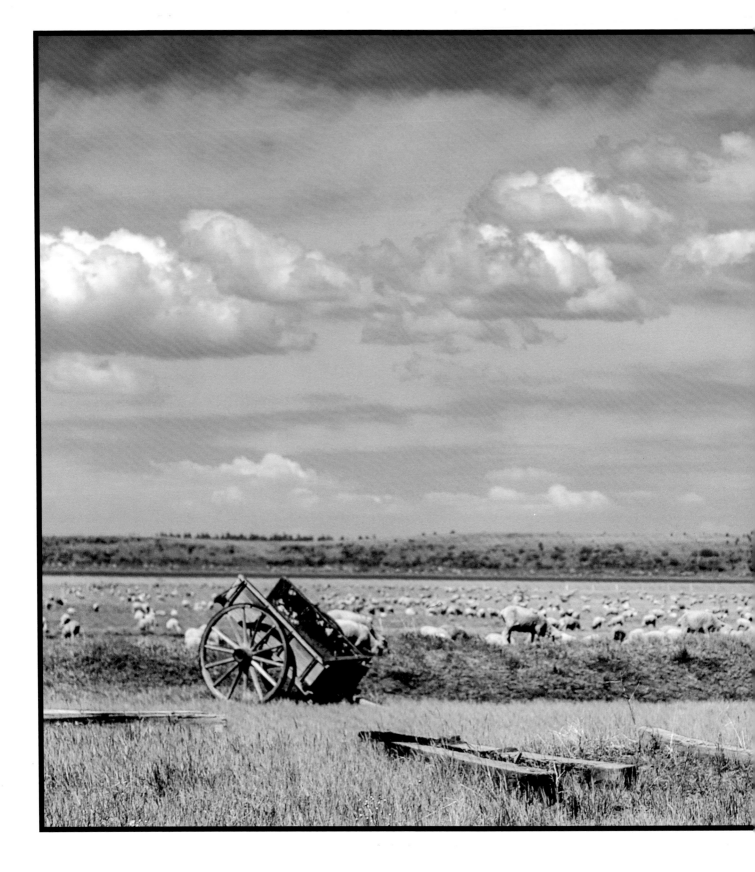

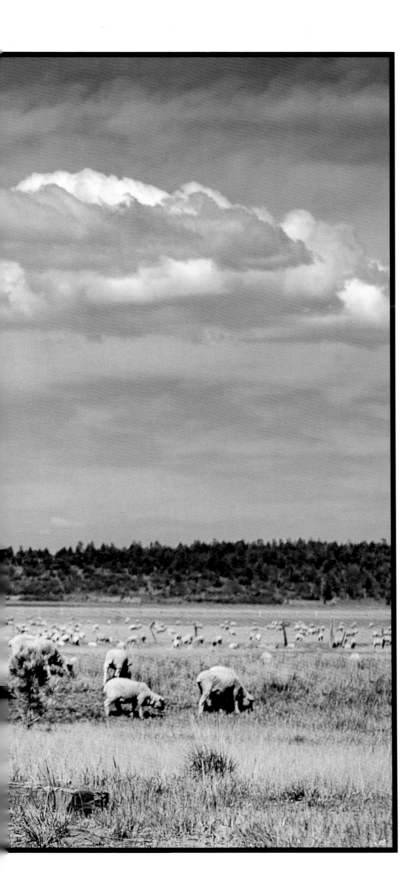

"My photographs have been taken primarily to record what Arizona looked like during my life," Barry said. "I intend that they be deposited with the Arizona Historical Foundation when I am no longer here to add to the collection." This photograph, titled *Sheep Grazing at Mormon Lake*, harks back to those earlier times. "A century ago in the Arizona Territory," Jo Baeza wrote in our November 1986 issue, "men fought and died over sheep. From Williams to St. Johns, along the Little Colorado and Puerco rivers, in saloons and on the open range, Northern Arizona was wounded by cattle-sheep wars."

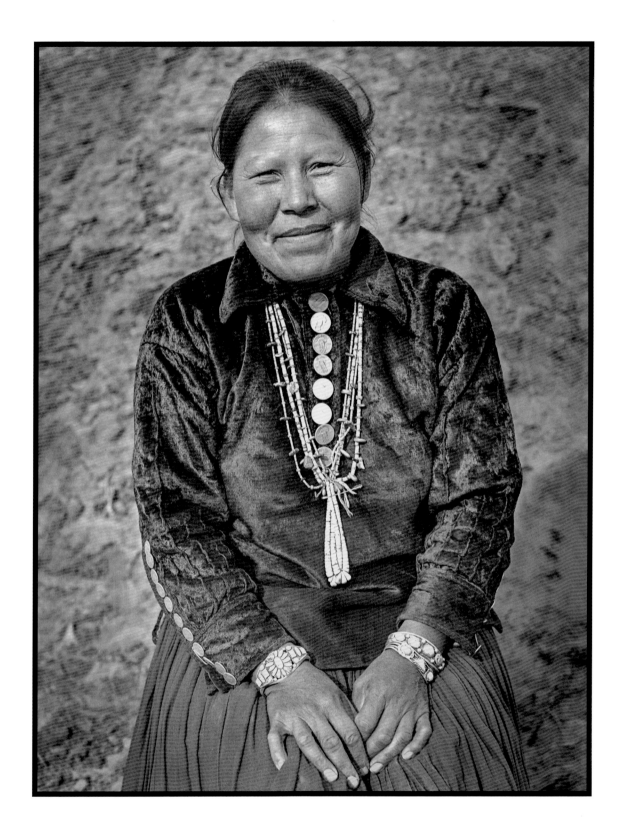

"The women used to dress up in their velvet jackets," Barry said, "and you could always tell the approximate worth of a family by the size [of the] coins she wore as buttons."

"I like portraits if I can find a good face," Barry once said.

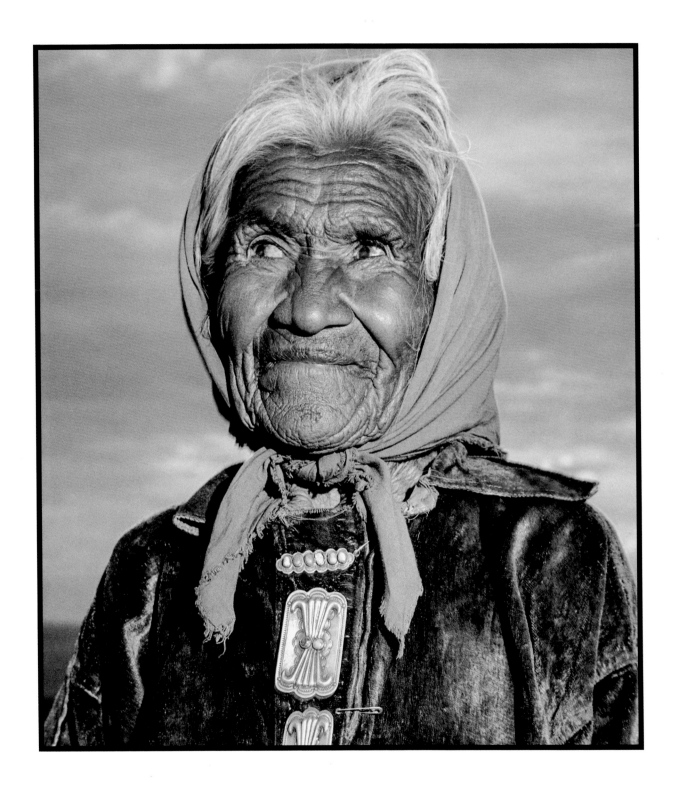

"Senator Goldwater's work captures moments when the technical limitations of film were nearly insurmountable. He had to traverse roads that were mere tracks in the mud, yet he came back with images that allowed everyone to see the backcountry of Arizona. The color work suffers from the inevitable comparison to today's images that can capture a more nuanced range of light, while his black and white images appear timeless. His composition, playing diagonals into corners and using the shadow line to mimic the ridgeline, makes for a strong image. The brilliance of the clouds supplies a destination for the eye to settle."

— JACK DYKINGA,
Pulitzer Prize-winning photographer

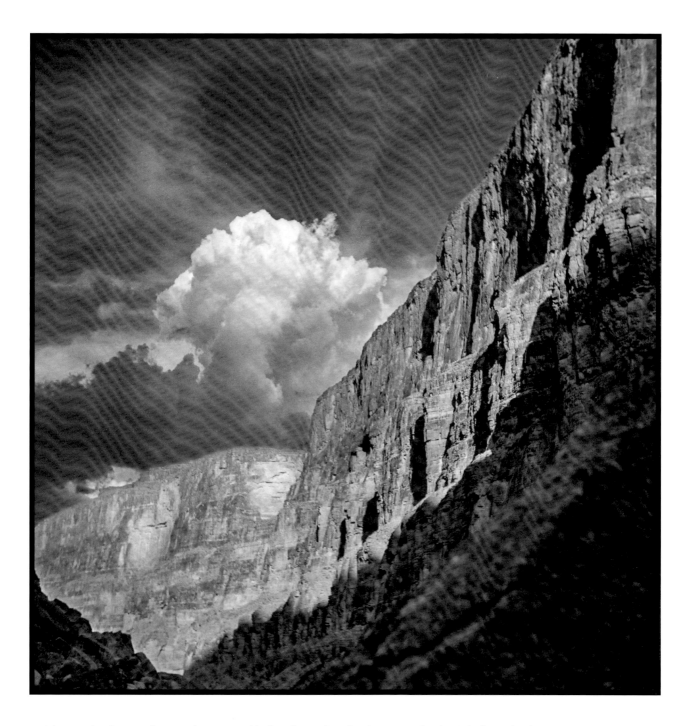

Like most landscape photographers, Barry liked to shoot when the skies were cloudy: "I think any landscape is more inter-esting where you have large cumulus clouds — the 'thunder bumpers,' as we call them — and they come in the afternoon, where you can show a mountain range with the beautiful clouds behind it, or a horse, or a windmill, or a fence with the clouds. I like clouds."

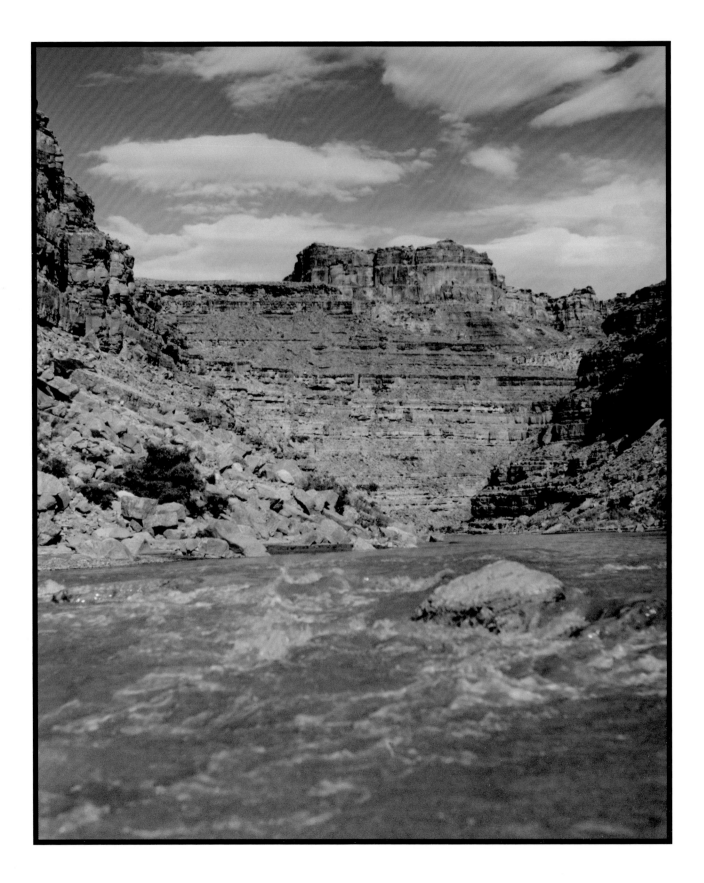

"In 1940," Barry wrote in his book *Delightful Journey*, "I fulfilled a lifetime ambition to explore by boat the Green and Colorado rivers." On that trip, he kept a journal. "This book of mine first assumed form as a diary scribbled and jotted each evening as we made camp; then it was published in a mimeographed edition of three hundred copies distributed privately among employees of the Goldwater store and my family. I also adapted a small portion of the text for an article that appeared in *Arizona Highways* in January 1941." That "short piece" of text ran 7,560 words, and the piece featured 70 of Barry's photographs from the trip. "The most remarkable thing, to me, all the way through the Grand Canyon, was that at no place did one have the feeling that one was in the world's largest canyon. Where we were able to see both rims, they would seem so far away that they looked like mountains. In fact, my impression all along, except when we were in the deepest gorges, was that we were going through a wide, deep valley."

"As a photographer one or two generations removed from Senator Goldwater, I can only judge his skills by his contemporaries. But given the times, equipment and skills necessary to get a decent photograph, he was pretty darn good. Today's photographers stand on the shoulders of photographers such as Barry Goldwater, Josef Muench, David Muench, Ansel Adams and Jerry Jacka, men who led the way in discovering this magnificent state."

— PAUL MARKOW, *photographer*

"No one has been able to identify the exact source or sources of the 'rules' of composition in the world of art. But I'm pretty sure they are closely linked to the shapes and structures of Earth's natural shapes and forms in geology and biology. In Barry Goldwater's photographs, I can see some of these natural guidelines — the curves of rock, for instance."

— GARY LADD, *photographer*

There aren't many places on the Navajo Nation that Barry didn't explore. But one of his favorites, his "piece of heaven," was Rainbow Lodge, a trading post that he co-owned from 1946 until it burned down in 1951. "While Dad was flying cargo missions during World War II," Michael wrote, "Mom arranged for Dad to become a partner in the Rainbow Lodge, located at the head of the trail leading down to Rainbow Bridge near Navajo Mountain. Built by S.I. Richardson around the turn of the 20th century, the lodge was situated in one of the most remote and picturesque regions of Navajo Country." The primitive "road" in the foreground of this image led to the lodge.

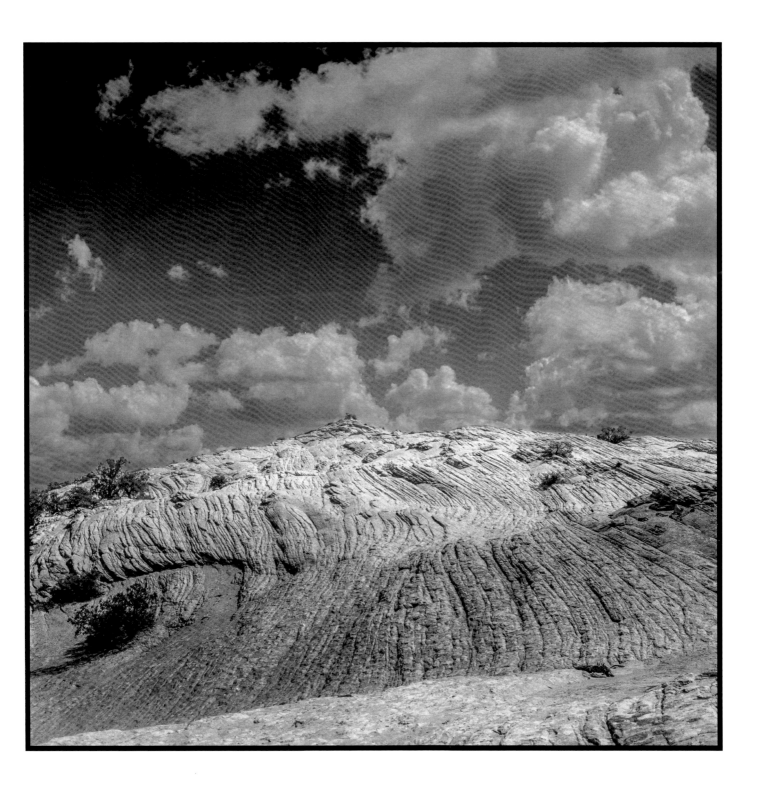

"I started taking pictures as a boy, using my mother's box camera," Barry said. "But I really got serious in 1934, when my wife, Peggy, bought me a camera for Christmas. It was an Eastman 2¼ x 2¼ Reflex. Then Tom Bates, a portrait-photographer friend in Phoenix, taught me how to make prints in his darkroom." This photograph is titled *Carrizo Creek Crossing*, which refers to a place on Apache land in northern Gila County.

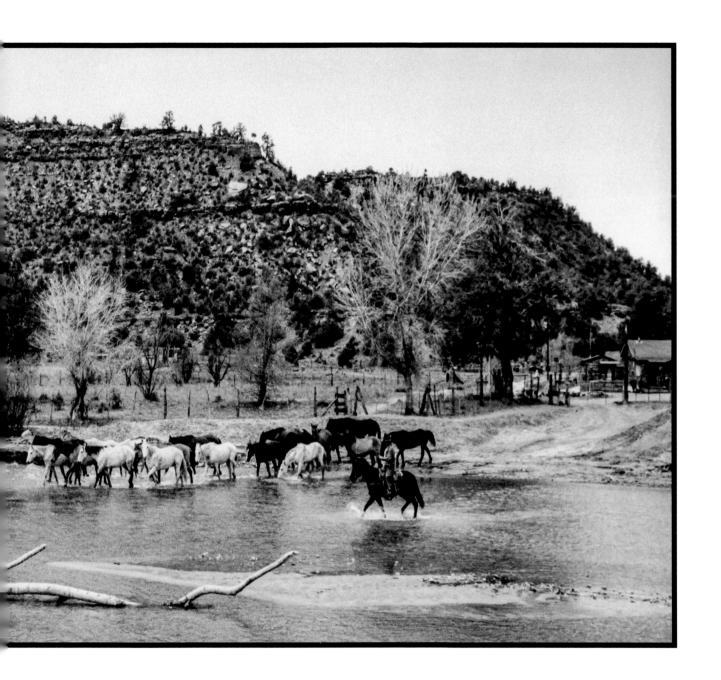

"Dad's belief in the value of direct experience was such that he oftentimes pulled us out of school for these trips, under the guise that we were off to study Arizona. And study Arizona we did to the extent that all four of us came to share his passion for off-the-beaten-path Arizona."

— MICHAEL GOLDWATER

"You can go anyplace in Arizona. Anyplace," Barry said. "From the Mexican border clear up to the Utah border, it is all photogenic. In the south, you have the desert. You have the biggest stand of pine trees in the world in the central part. We have mountains that go up to 12,000 feet. Our lowest elevation is about 50 feet. There's just no end. You can literally spend your life out there and never quite get it all."

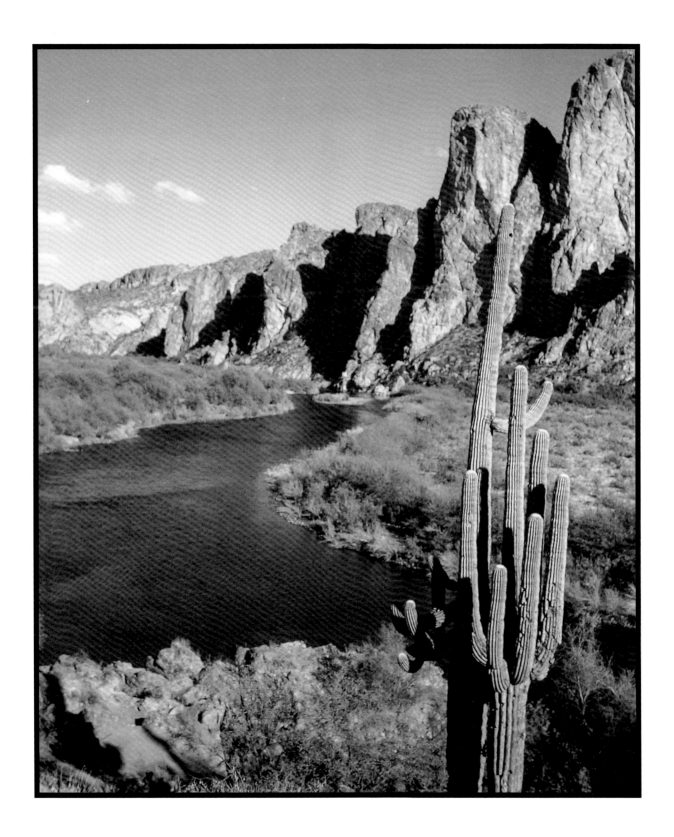

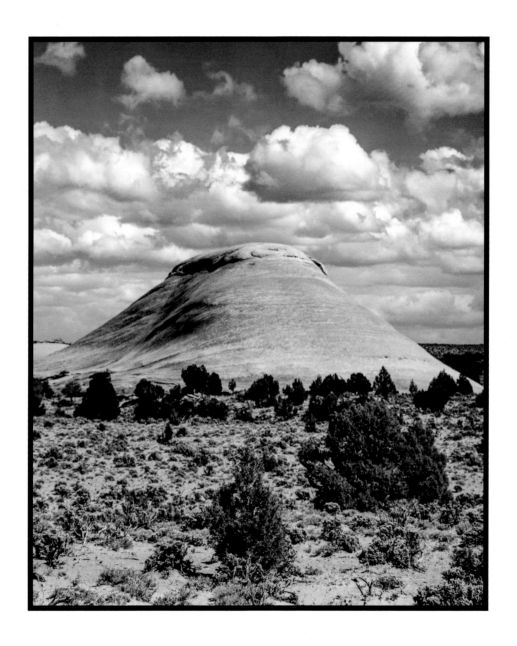

"The fun is getting the picture," Barry said. "You see a picture, and you take one or two or three negatives. I don't believe in taking hundreds of negatives of one subject. I take usually one or two, and if I don't get it ... I don't get it. But out of that one or two, you're bound to get a picture someplace."

"Landscape photography is very simple," Barry said. "You just go out and look for something and take it." In the case of this photograph, which was featured in our July 1947 issue, he went out and found what would come to be known as Margaret Arch. Although he didn't "discover" the arch, per se, he is credited with being the first person of European descent to see and photograph the landmark, which is named for his wife, Peggy.

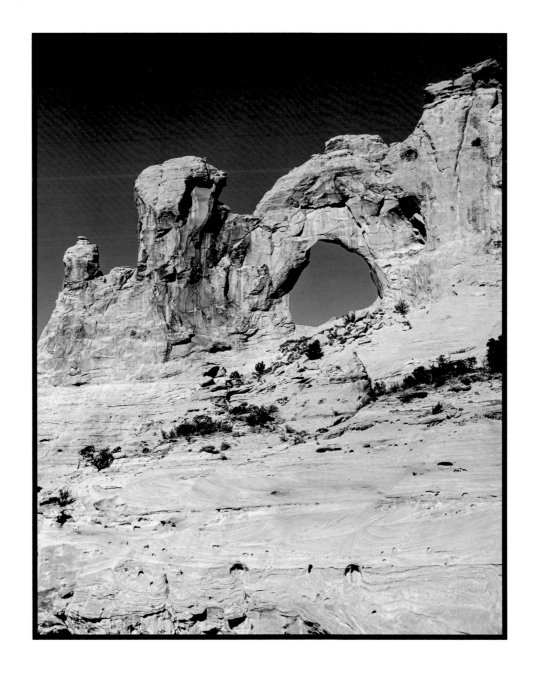

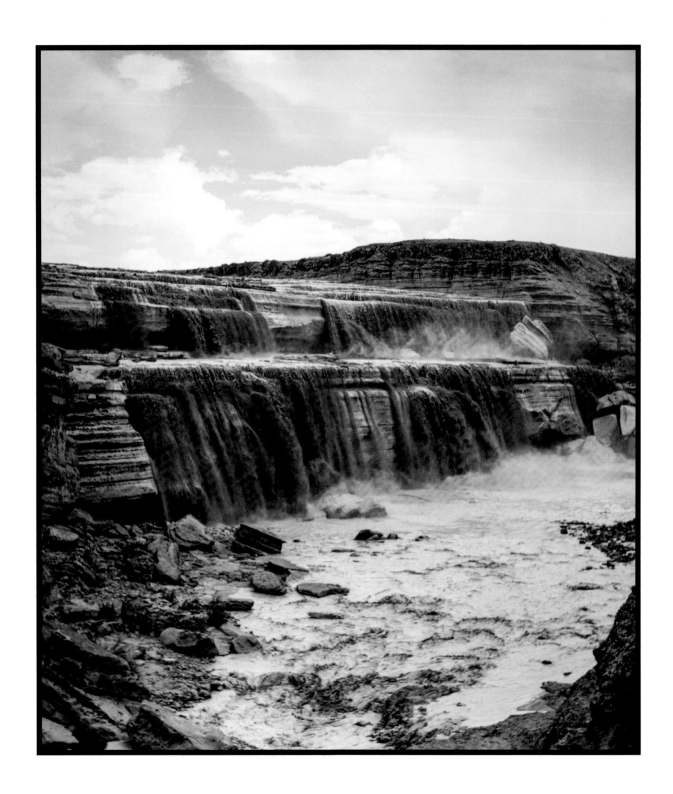

Barry made several photographs of Grand Falls, including one that ran in our July 1953 issue. The negative for that image could not be found, but this photograph likely was made at the same time. About the falls, in that 1953 issue, Editor Raymond Carlson wrote: "The Little Colorado, which begins its life in placid and cool springs in the White Mountains, at times becomes a rowdy and turbulent stream in its journey to the Colorado near Cameron. When rains are heavy, the stream tears up a lot of country, which it pours as silt into the Colorado. This is dramatically shown at Grand Falls, about 35 miles north of Flagstaff. When the river is full, you see a cascade of mud, which tells of the cruel cutting power of the river."

"I've published six books of photography and I was a salon exhibitor before World War II. And I was very active with *Arizona Highways* — I am the oldest photographer that they have."

— BARRY M. GOLDWATER

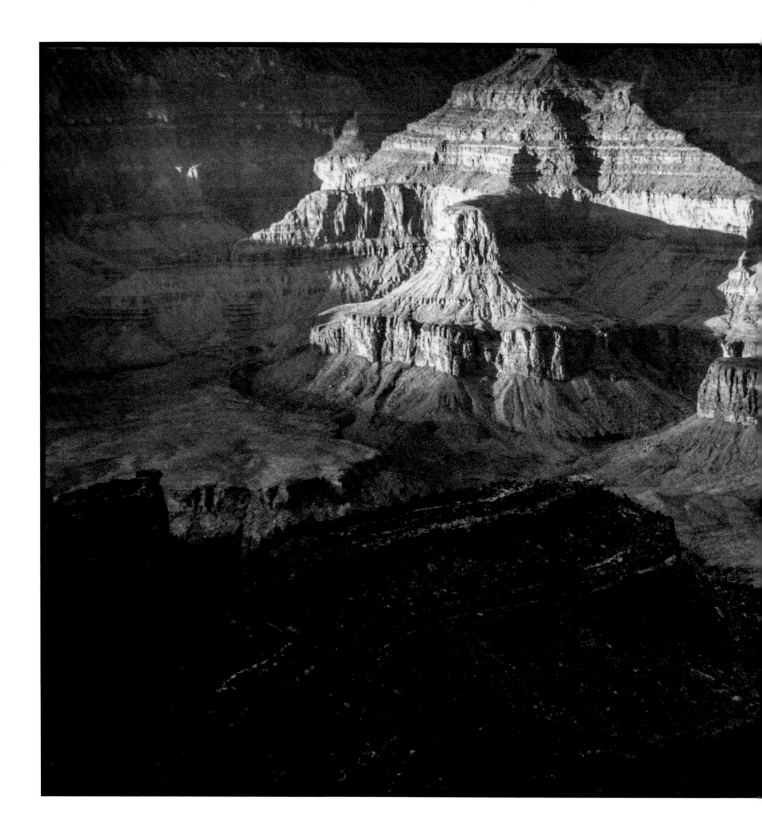

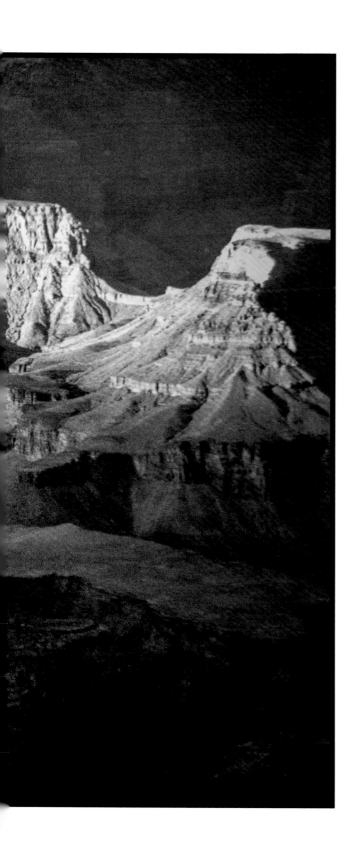

"People often ask me to recommend the best way to see the Grand Canyon or the best time to see it," Barry wrote, "meaning not only time of day, but time of year. To tell the truth, it is absolutely breathtaking and beautiful at any time and in any season. But my favorite way to see the Grand Canyon is to rise before the sun even thinks of getting up, find a seat on the edge of the rim, and just sit and watch as the light of the dawning sun begins to illuminate the rock formations in the Canyon, painting them from top to bottom."

"I have photographs I've taken in South America that I'm very fond of. I've been to the South Pole — pictures that I've taken down there that I like. But I still like Arizona better."

— BARRY M. GOLDWATER

"I think [photography] is art," Barry said. "I think it's becoming more art than it used to be, thanks to people like Ansel Adams and Edward Weston and some of the modern photographers who do art type of photography." This photograph, which is among the family's favorites, was published in our July 1949 issue.

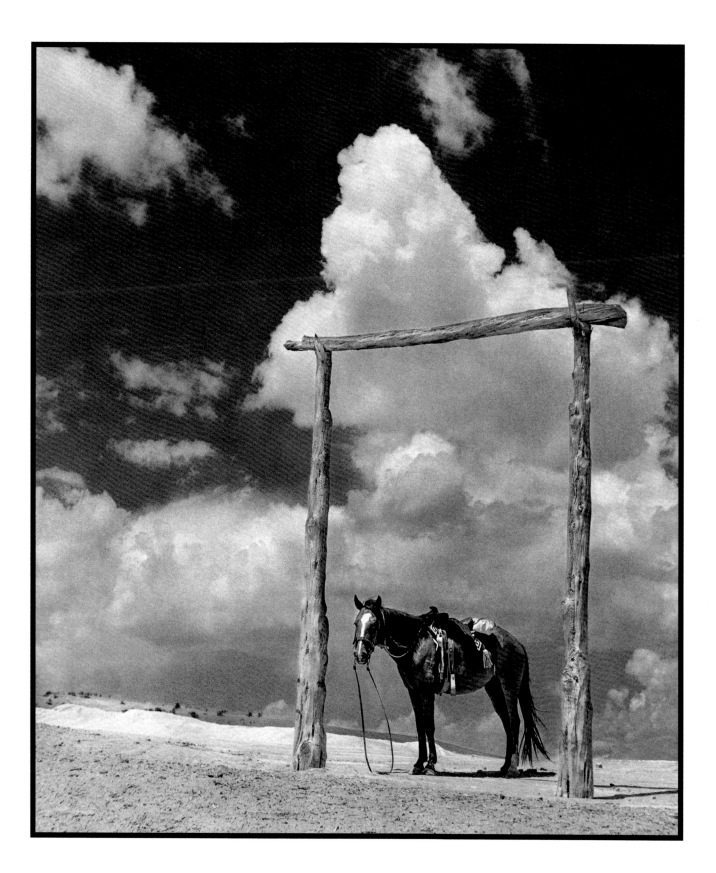

A PASSION AND A PURPOSE

BY ANNA GOLDWATER ALEXANDER

I knew him as a grandfather and a photographer, long before I learned what other people knew him to be. To them, Barry Goldwater was an American politician — a five-term U.S. senator and the 1964 Republican Party nominee for president of the United States. But I didn't pick up on any of that until I moved from the liberal enclave of Marin County, California, to Phoenix, Arizona, when I was 12 years old. Unfortunately, his loss in that 1964 election is what he's most remembered for, but there's so much more to his story. Among other things, he was a skilled and dedicated photographer. And it wasn't just a hobby. It was a passion and a devoted purpose.

Maybe I overlooked the politics and saw him as a photographer because that was my sole interest — the thing that drew me to him. Or maybe it's because it was the one thing about him that wasn't controversial in the public realm. Like all politicians, he learned to live with the understanding that not everyone would agree with every one of his viewpoints. After all, that's the role of a public servant: to choose a position, stand up for it and deal with the pushback. My grandfather embraced his public obliga-

tion, but I think he was grateful to have something else that was just *his*.

Documenting the people and places of Arizona was personally rewarding and publicly nonjudgmental. As a politician, he had to be whom he was *expected* to be, but as a photographer, he got to be whom he *wanted* to be: a statesman who recorded Arizona history through the lens of a camera.

MY GRANDFATHER IS KNOWN around the world as Senator Barry M. Goldwater, but that's not what I called him. I called him "Paka." All 10 of his grandchildren called him that. I think the name originated with my cousin Carolyn, his first grandchild. I'm the eighth grandchild of a man who was born in Phoenix on New Year's Day in 1909, three years before Arizona became a state.

His strength came from his mother, Josephine. Whether he was speaking his mind on the Senate floor or asking to take photographs with his "Rollei" on the Navajo Nation, his audacity came from her. I wish I could have known my great-grandmother, but I'm proud to say

124

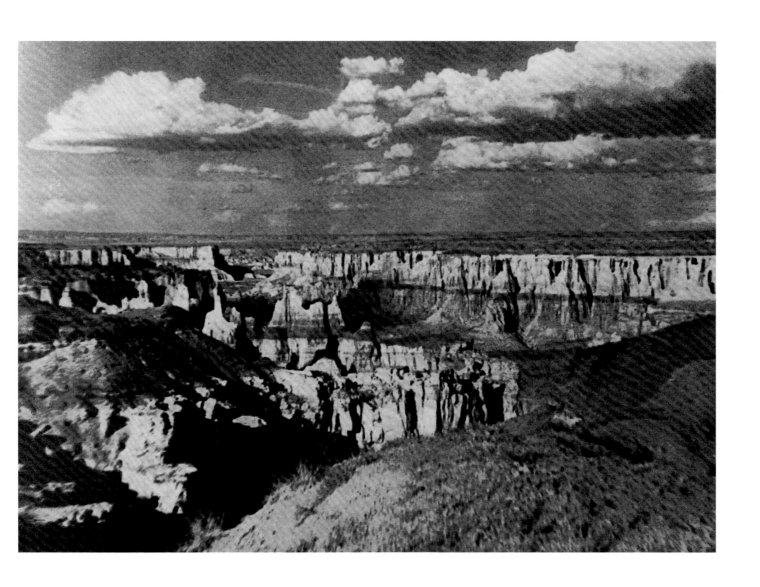

Over the years, *Arizona Highways*
published hundreds of photographs by
Barry Goldwater. The first was this shot
of Coal Mine Canyon, which ran on
page 16 of our August 1939 issue.

that her "bravery" genes and her "saying what needs to be said" genes were passed on to all of her granddaughters, all of her great-granddaughters and *definitely* all of her great-great-granddaughters (one of whom is an amazing, aspiring photographer at the age of 16).

Photography is in the blood — I'm a big believer in that. My father, Michael, got the gene from Paka, so I was surrounded by it growing up. And I knew early on that I'd spend my life working in the field of photography. I'm very fortunate. I love what I do — being a photo editor. Portraits, scenic landscapes, documentary photographs, even product shots ... I get to look at photos all day. That's my "job." But it also keeps me connected to Paka.

Growing up, our conversations were mostly art-based. That's because he caught me in the darkroom so many times. And because I'd stand in his guest bathroom for hours and stare at the "photographic wallpaper" he'd made out of black and white prints. (Imagine Tetris played with 35 mm photographs — every image fit perfectly into a grid.) Although the wallpaper was made up of party photographs, that's not what my grandfather was known for. In fact, he authored six photography books on subjects other than parties and politics.

He got serious about photography in 1934, when my grandmother — "Nana" to me, Peggy to him — gave Paka a 2¼ Reflex camera as a Christmas gift. Nana was an art-ist, too, with a degree from the Grand Central School of Art in New York City. Because of her own skills, she was able to offer her husband some pointers on composition and positioning. Nevertheless, they often argued over where the "main accent" should be in each frame. (Side note: Thank you, Nana, for the "art" gene.)

Although it was Nana who inspired his love of photog-raphy, it was Josephine who piqued his interest in Arizona. She would often take my grandfather and his two siblings, Carolyn and Bob, camping in the backcountry. She taught them about the Grand Canyon State and to respect its Native people. Their adventures led them all over Arizona, with extended time spent on Navajo, Hopi and Apache tribal lands. Through those experiences, Paka gained an unshakable appreciation for the desert and all of its inhab-itants — every human, creature and cactus.

I'D LIKE TO THINK I GOT TO KNOW my grandfather's photography — specifically his technique — better than anyone. I graduated from the University of Arizona with a bachelor's degree in photography. Right after college, I was asked to help the Arizona Historical Foundation make 8x10 prints of each of Paka's negatives and put them in binders for their archive. It was a dream job, and it took a year to complete the project. In that time, I learned a lot about my grandfather's photographs, which were 4x5 inch,

6x7 cm and 2¼ inch negatives in black and white. The negatives I worked with were cut into singles — away from their strips — and placed in delicate sleeves. His writing was on each slide, typically indicating the date, the location and maybe the subject's identity. I printed about 30 a day and rarely needed to adjust anything.

I learned early in the process that even though he often used a yellow filter to help tame the Southern Arizona sun and the Northern Arizona snow, those moments still needed to be burned in. There was no Photoshop in the darkroom; it was all done with dodging and burning. But I loved my time in the darkroom. It was so peaceful in there, all alone, taking a photographic journey with my grandfather, whether it was rafting the Colorado River with his family or visiting with the Hopi people.

Every image is special, but what really drives me to Paka's photographs are the landscapes. He used his 4x5 Graflex, and then his Rolleiflex, for most of his black and white film. Those two cameras conquer depth of field like no other, by way of shooting at the smallest aperture permitted by the lens, in the style of Edward Weston. Paka had great admiration for Mr. Weston, and also for Ansel Adams, whom he first met in Navajoland. Mr. Adams advised my grandfather on technical form with the camera, and Paka suggested the proper etiquette for making photographs on Native lands. (You should always ask before shooting.)

Fortunately, Paka was still alive when I started the project for the foundation, so I was able to ask him about his photography. He enjoyed the memories but got very emotional when he spoke about about his family and Arizona. He had so many stories to tell.

Looking back, I wonder about his approach to photography. Did he take enough film to just keep shooting and shooting? Or did he savor the scene and set up the shot? I also think about how he'd shoot in the digital age. Would he cling to his beloved film? Or would he take advantage of the ability to shoot nonstop, without reloading? I suspect he would have welcomed the modern world of photography — he understood the value of technology and supported its growth.

Regardless of the equipment, my grandfather always sought out the challenges of composition when shooting. He was very thoughtful about his art. And when I go back through his archive today, I can't help wondering whether he realized that his beautiful photographs not only documented history, but also revealed the sensitive side of his dynamic personality.

In addition to being a proud granddaughter, Anna Goldwater Alexander is the director of photography for Wired *magazine.*

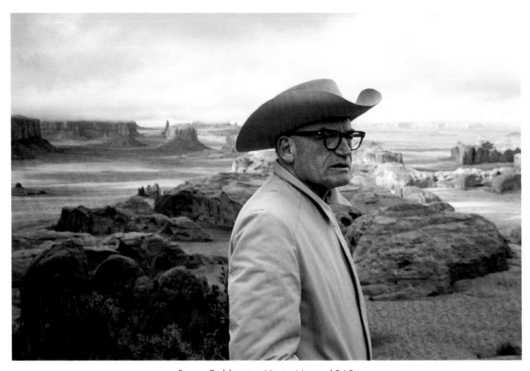

Barry Goldwater, Hunts Mesa, 1968

AT THE END OF THE DAY...

"Barry Goldwater's photographs should be viewed as visual love letters crafted by a gifted artist with a facile mind wedded to a cause larger than his own axis. What began as a hobby turned into a lifetime pursuit that enabled him to 'pay rent' in ways and arenas as boundless as the landscape he routinely celebrated as home. Beauty stirred his senses, but conscience controlled his hand. The evidence rests richly in his photographs, which are best viewed as two-dimensional windows into the soul of a human dynamo far too intrigued with the fine art of doing to ever pause long enough to admire the sophistication that kept him forever uncommon."

— Evelyn S. Cooper, *The Eyes of His Soul: The Visual Legacy of Barry M. Goldwater, Master Photographer*